IMAGES
of Rail

THE LIGONIER VALLEY
RAIL ROAD

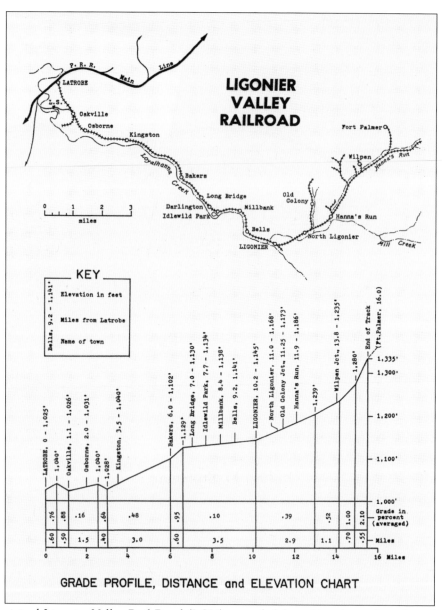

The original Ligonier Valley Rail Road (LGV) extended from Ligonier to Latrobe, where it connected with the Pennsylvania Railroad (PRR). In 1899, the LGV extended its track southeast to the Byers-Allen sawmill and the Pittsburg, Westmoreland & Somerset Railroad. (Pittsburg was the correct spelling in 1899.) Five years later, LGV began construction on a new line to access the rich coalfield northeast of Ligonier. That extension became known as the Mill Creek Branch. (Courtesy of Russ Lowden.)

ON THE COVER: On August 31, 1952, the Last Run of the LGV was organized by the Ligonier Valley Chamber of Commerce to commemorate the railroad's contributions to the region over its 75 years. More than 400 people bought round-trip tickets between Ligonier and Latrobe for the Last Run, which included ceremonies at both ends of the line. Residents waited in line to have their photographs taken in front of No. 807. (Courtesy of Ray Kinsey.)

IMAGES
of Rail

THE LIGONIER VALLEY
RAIL ROAD

Robert D. Stutzman

To Bob
Happy Rails to You!
Bob Stutzman

ARCADIA
PUBLISHING

Published by Arcadia Publishing
Charleston, South Carolina

Printed in the United States of America

Library of Congress Control Number: 2013943175

For all general information, please contact Arcadia Publishing:
Telephone 843-853-2070
Fax 843-853-0044
E-mail sales@arcadiapublishing.com
For customer service and orders:
Toll-Free 1-888-313-2665

Visit us on the Internet at www.arcadiapublishing.com

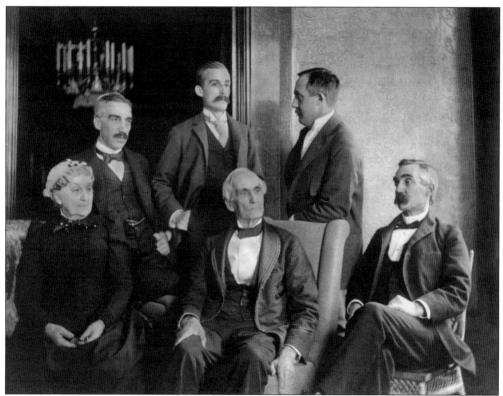

In 1877, Judge Thomas Mellon, together with his wife, Sarah Negley Mellon, and their four sons, built a railroad to connect Ligonier with the Pennsylvania Railroad in Latrobe with the intent of opening up Ligonier Valley for development. This 1890s photograph shows, from left to right, (first row) Sarah, Thomas, and young Thomas; (second row) James, Andrew, and Richard. (Courtesy of the Pennsylvania Room of the Ligonier Valley Library.)

CONTENTS

ACKNOWLEDGMENTS

Writing this book has been a labor of love for this author, who realizes that it would have been impossible without the efforts of many people and organizations. The owners, the management team, and the employees of the Ligonier Valley Rail Road (LGV) created the story, and the long-ago efforts of anonymous photographers made this book possible. The limitation of space precludes listing the scores of contributors who have donated photographs to the Ligonier Valley Rail Road Association (LVRRA). Regardless, I would like to express my personal gratitude to each one. Their combined efforts have resulted in the LVRRA's collection of photographs, which, I believe, is the most valuable asset of the organization. All images shared in this book, unless otherwise noted, appear courtesy of the LVRRA.

Additionally, numerous individuals have contributed their time. Former employees of the railroad assented to be interviewed. They include Jake Burns, Elroy Byers, Homer McMaster, Carl Tantlinger, Al Trautmann, and John Volpe. Local historians also offered input, including Ed Concus, Jeff Croushure, Paul Fry, Scott Graham, Shirley Iscrupe (an astute fact-checker), Ray Kinsey, Ted Labuda, Russ Lowden, Bill McCullough, Sally Shirey, Bill Stouffer, Bob Stump, and John Vucina.

Jim Aldridge, a longtime friend and railroad historian, has donated countless hours to this project. He helped to select and organize photographs and contributed to the content of captions. Carolyn Dillon, a high school classmate and friend, has also donated many hours as my editor, helping me to clarify my thoughts and ideas and to express them precisely. Most of all, I acknowledge my best friend, my wife, Carolyn, who has so ardently supported me in my effort to write this book.

INTRODUCTION

When the Pennsylvania Railroad (PRR) selected its course between Altoona and Pittsburgh in 1852, it passed through Latrobe, some 10 miles west of Ligonier. Until that time, Ligonier was positioned along one of the major east-to-west arteries involved in the country's westward expansion. When the railroad bypassed Ligonier, residents realized their thriving community would suffer economically because of the decrease in trade and tourism. In response, an initiative was launched to build a connecting railroad that would follow the Loyalhanna Creek, which had carved a gorge through the Chestnut Ridge, to interchange with the PRR in Latrobe. A railroad charter was granted; however, the railroad itself never materialized.

The concept of building a railroad to connect Ligonier to the PRR lay dormant for almost 20 years until another group of businessmen organized and gained permission to modify the original charter to build the Ligonier Valley Rail Road (LGV). After the entrepreneurs sold stock to fund their enterprise, they purchased most of the necessary rights-of-way and graded much of the roadbed before the Panic of 1873 forced them into bankruptcy. Still believing the connecting railroad was of paramount importance for Ligonier and the valley to stay connected to the growing American economy, the officers of the LGV continued to search for financial backing for another four years.

Upon approaching Pittsburgh businessman Judge Thomas Mellon in 1877, the officers of the LGV finally found a sympathetic listener, but one not initially impressed with the viability of a short-line railroad in the foothills of the mountains east of Pittsburgh. However, when Mellon's sons learned of the opportunity, they became ardent champions of building the railroad. Soon after, the sons—James, Thomas, Andrew, and Richard—conducted a survey of the traffic between Ligonier and Latrobe, hoping to convince their father that such a railroad could be profitable. James's nine-year-old son William was positioned along the state road near present-day Kingston to count the number of wagons and buggies passing through the gorge as well as to record the contents in each wagon and the number of passengers in each buggy. The judge eventually agreed to back the LGV, in part because he believed that such a venture would provide his sons with an invaluable lesson in life.

To save money, the judge stipulated that a three-foot, narrow-gauge, light-rail system be used with secondhand engines and coaches. The LGV was a single-track system that accommodated both passenger and freight trains and employed wyes at both ends of the line. In anticipation of the problem of LGV's narrow-gauge (36-inch) track interchanging with the PRR's standard-gauge (56.5-inch) track, the LGV installed, in October 1877, the recently invented Ramsey car-truck-shifting apparatus, the first narrow-gauge-to-standard-gauge installation in the United States. The system elevated a PRR railcar to release its standard-gauge trucks, which employees then

replaced with narrow-gauge trucks. Once the transfer was made, the railcars were then able to traverse the narrow-gauge tracks of the LGV. Upon the railcar's return to Latrobe, the procedure was reversed. Although functional, the process was labor intensive, and, after only five years, in 1882, LGV replaced its narrow-gauge tracks with standard-gauge tracks and rolling stock.

The LGV hired the best employees by enticing them with wages 10 percent higher than the wages paid by the PRR. Additionally, it used an innovative incentive program to lay the track. At the beginning of each workday, young Thomas Mellon would drive his buggy, loaded with an iced-down keg of beer, to where his workers were laying track, and tell them that once they reached the keg, which he would unload somewhere down the roadbed, they could drink it. This incentive always worked. Once the Mellon brothers took over the operation of the railroad, within two months, the grading, bridge building, laying of track, and acquisition of equipment were completed. The entire family was involved, even Sarah Mellon, who "decorated" the first LGV coach, having it freshly painted with new curtains hung. After the line was completed, *Railway World*, in the December 22, 1877, edition of its magazine, announced: "This new narrow-gauge railroad, from Latrobe to the romantic village of Ligonier, was formally opened December 15th with appropriate ceremonies."

As majority owner of the railroad in 1877, Judge Thomas Mellon retained S.H. Baker as president and J.W. Murdock as secretary/treasurer. The judge became the solicitor for the board while three sons became officers. Thomas was named general superintendent, Andrew was appointed cashier, and Richard became the general freight agent. Enthusiastically, Richard also worked as a conductor, a baggage handler, an occasional engineer, and in any other capacity he could find. The eldest son, James, was named the general auditor and passenger agent in 1879. On March 3, 1887, the Mellon family bought out the minority owners of the railroad, and the LGV became the only enterprise in which the judge and his four sons were all active participants. The Mellon family continued their presence on the board during the LGV's operation.

Throughout their ownership of the LGV, the Mellons treated their employees well. Only three general managers were engaged to manage the daily affairs of the LGV over the 75-year history of the railroad. LGV pioneered a pension plan for its employees, nearly a decade ahead of the National Railroad Act. Even when the railroad shut down in 1952, employees were awarded severance pay proportional to the length of their service. For example, John Holman received one year's pay plus earned vacation time for his 45 years of service.

Both passengers and industry welcomed the new railroad. Ligonier residents could travel to Pittsburgh in less time than it had taken them to travel to Latrobe by horse and buggy. Likewise, the town of Ligonier, with its reputation of being a mountain retreat, was now only two hours away from Pittsburgh. To increase patronage on the railroad, in 1878, Judge Mellon conceived the idea of developing Idlewild Park as a fresh-air, clean-water destination away from the smoky city of Pittsburgh. Idlewild Park, with its shaded picnic groves and man-made lakes, made an attractive alternative to the daily grime of the city. Numerous organizations planned annual reunions at the park. Workplaces, social lodges, communities, and churches scheduled picnics at Idlewild Park, and the railroads (PRR and LGV) accommodated the events. An 1892 Reformed Church reunion required 130 coaches to transport some 9,000 picnickers to Idlewild Park. For the annual Lutheran Day in 1895, a group of 10 special PRR trains pulling a total of 85 coaches and 10 baggage cars plus regularly scheduled trains from Latrobe and Ligonier were needed to transport another 8,000 picnickers. The LGV enabled both day visitors and tourists the opportunity to experience the beauty and tranquility of Ligonier Valley. Tourism boomed and the combination of Ligonier Valley and Idlewild Park became known as Pennsylvania's Mountain Playground.

To gain rail access, numerous industries located their plants along the first three miles of the LGV line originating in Latrobe. These plants included steel mills, a manufacturer of molds for the steel industry, and a roofing-paper plant. Coal mining operations also located shafts near the LGV line. Nearby, in Kingston, brickyards developed where they had access to both raw material and rail transportation. Existing industries, such as the rock quarry in the Loyalhanna Gorge, expanded once they gained an economical means of transporting their products via the

LGV. On the Ligonier side of Chestnut Ridge, industries involving lumber, bark, and ice also began to prosper.

By far the largest industry supported by the LGV was related to the eight-foot seam of coal known as the Pittsburgh Seam, which outcropped in several places north of Ligonier along Mill Creek. As early as 1872, when the LGV charter was modified, the owners recognized the potential for developing the coalfield. Due to economic reasons, the LGV did not venture north of Ligonier into the coalfields until prompted to do so by the Westmoreland Central Railroad (WCR) endeavor in 1903. The Seger brothers, John and Samuel, had purchased considerable coal and timber rights in Ligonier Valley and were anxious to begin mining. Still without a railroad in 1903, they formed their own, the WCR, and actually began to grade the right-of-way already owned by the LGV. At their initial plant, Colonial Coal & Coke Works, mine portals were opened, a tipple was being erected, and coke ovens were being built even before a rail line had been established. After some litigation, an amicable agreement was arranged between the WCR and the LGV. The ensuing coal industry generated enormous economic growth in the area. In order to house the miners and coke plant workers, within one decade, the company towns of North Ligonier, Old Colony, Marietta, Wilpen, and Fort Palmer sprang up along the Mill Creek Branch.

For 35 years, the LGV operated on an informal verbal-order basis and had a clean safety record. Tragically, this changed when the informal procedure caused a wreck that should have been prevented. On July 5, 1912, the conductor of a passenger train was given a verbal order to hold his train in Ligonier until a freight train from Wilpen arrived. The order did not account for the existence of a second freight train already in the Ligonier yard. Thus, the verbal order was misinterpreted when the passenger-train conductor saw the second freight train in the yard. Assuming it was the one he was to wait for, the conductor directed the passenger train to proceed to Wilpen. Only 1.2 miles from Ligonier, the passenger train met the oncoming freight train as it rounded the only blind curve on the Mill Creek Branch. The head-on collision killed 24 passengers and crew members. Miraculously, almost 40 people survived the crash. Immediate corrective actions were placed in effect to prevent a recurrence. Regardless, the Interstate Commerce Commission found the operating procedures of LGV to be "extremely faulty."

The construction of the LGV track originated in Latrobe and worked its way toward Ligonier and beyond. This book is organized geographically and follows that same route. At times, the use of an abbreviation is readily apparent, such as the use of PRR in place of Pennsylvania Railroad. In other cases, such as LGV, the relationship is not as obvious. At least 10 railroads in the United States qualified to use the initials LVRR, including Lehigh Valley, Lycoming Valley, and Ligonier Valley. To avoid being confused with other railroads, the Ligonier Valley Rail Road adopted the "LGV" reporting mark in 1914. Likewise, LGV is used as the abbreviation for the railroad throughout this publication.

The idea of creating a pictorial history of the LGV originated with a PowerPoint slide show presented in 2002 at the Ligonier Valley Library to commemorate the 50th anniversary of LGV's Last Run. The Pennsylvania Room at the library, in the process of launching a series of annual exhibits regarding the history of the Ligonier Valley, chose the LGV as its inaugural exhibit. The library asked this writer and his brother-in-law Bill McCullough to share their collection of LGV photographs. That library exhibit and the amount of interest shown in the history of the LGV led to the creation of the Ligonier Valley Rail Road Association (LVRRA), a nonprofit 501(c)3 organization incorporated in 2004 to preserve the legacy of the LGV. This book shares LGV-related photographs, arguably the most valuable asset of the LVRRA. They have been contributed by scores of individuals and organizations and tell the story of the LGV and its impact on the local community.

Although a bibliography appears on page 127, additional information about three sources is warranted. The most comprehensive reference regarding the LGV is the 1955 doctoral dissertation "The Ligonier Valley Rail Road and Its Communities," by James Madison Myers. While writing his dissertation, Myers was granted access to the official records of the LGV and the scrapbook maintained by general manager Joseph P. Gochnour Jr. These records have since disappeared. The

dissertation is available to readers who wish to learn more about the LGV and may be ordered through ProQuest Company, at 300 North Zeeb Road, P.O. Box 1346, Ann Arbor, Michigan 48106. Another authoritative source of information is the roster of LGV equipment compiled by Jim Aldridge. A dedicated researcher, Aldridge maintains the roster as a living document with updates incorporated as new information becomes available. The roster provides specific information regarding all LGV equipment and is available at the Ligonier Valley Rail Road Museum. Additionally, the website of the Ligonier Valley Rail Road Association, www.lvrra.org, designed by Bill Potthoff, provides a search feature to access digitized newspaper files relating to the LGV.

The history presented herein cannot include every aspect of and contribution to the story of the LGV, and omissions are inevitable. My best effort has been made to present an accurate story of the railroad. Please forward any comments, corrections, or observations regarding this book to Robert.D.Stutzman@gmail.com. Any corrections, additions, or amplifications to this text will be posted at www.lvrra.org. Thank you for taking your time to read about the Ligonier Valley Rail Road.

One

THE FIRST THREE MILES

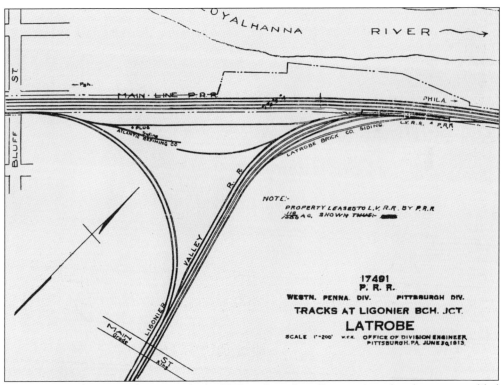

LGV's wye and its interchange with the PRR in Latrobe, illustrated in this diagram, enabled LGV equipment to turn around for the return trip to Ligonier. The wye also provided storage and interchange tracks to accommodate empty inbound hopper cars delivered by the PRR as well as outbound hopper cars loaded with coal, coke, or gravel.

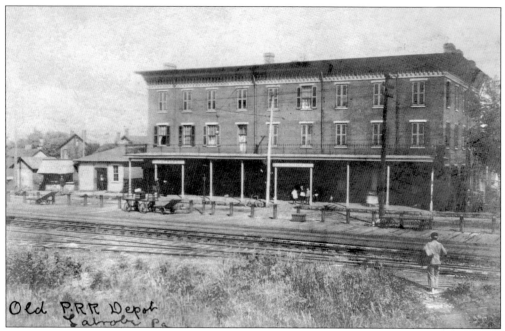

Old P.R.R. Depot
Latrobe Pa

This undated photograph shows the PRR's Latrobe station, located in the Clifford House Hotel on Railroad Street, midway between Ligonier and Alexandria Streets. In 1877, when the LGV began to operate, its station and platform (not pictured) stood less than one block away.

This photograph, taken before 1903, provides an early glimpse of LGV's track merging with the PRR. In the foreground are the east-west tracks of the PRR. Immediately behind those tracks, next to the raised platform, is the connecting track between the two railroads. Visible on the right edge of the photograph is the corner of the one-story baggage room at the LGV's Latrobe station.

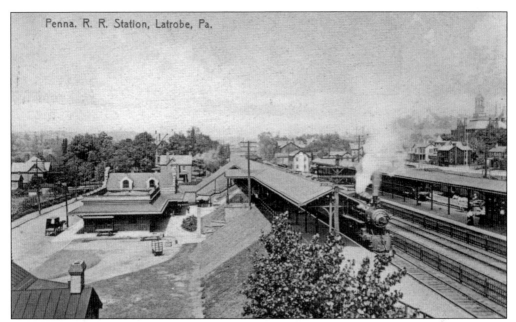

Penna. R. R. Station, Latrobe, Pa.

By 1903, the PRR had added two additional tracks, elevated its line through Latrobe to avoid grade crossings, and built a new station. A westbound PRR train is seen here making a stop on the No. 4 track while a LGV train awaits its departure time beyond the eastbound platform on the right. The white building in the center of the background served as the LGV station until 1903.

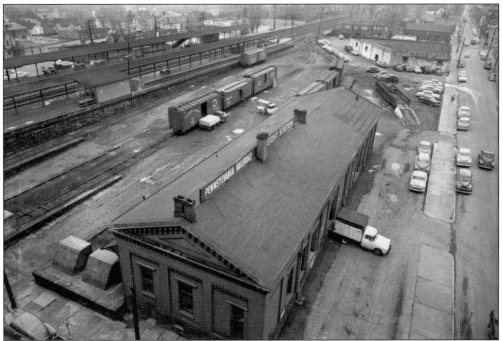

This view of PRR's freight station and yard in Latrobe, taken around 1950, shows the westbound and eastbound passenger platforms of the PRR on the left. The PRR shared its eastbound platform with the LGV, which accessed it on the stub-end track to the left of the single boxcar in this image. The wye, which enabled the LGV to interchange with the PRR, is two blocks east of this site.

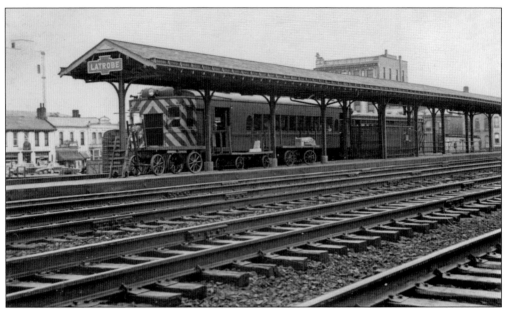

The LGV owned four self-powered doodlebugs, all purchased between 1928 and 1943. In this late-1940s view, the No. 1152 gas-electric doodlebug stands at the Latrobe platform waiting for passengers to board. Coupled behind No. 1152 is the M-10, another doodlebug, in use as a trailer. This consist was used when a larger number of passengers than usual was anticipated. In the foreground is the four-track main line of the PRR.

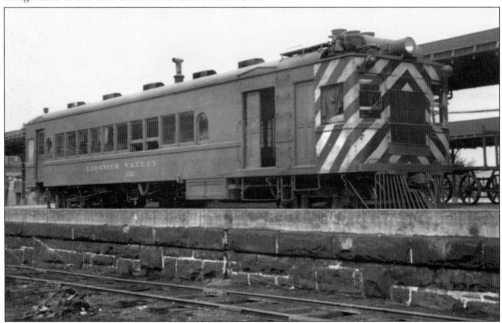

As seen from the PRR freight yard, one of two gas-electric doodlebugs on Ligonier's equipment roster, No. 1150, is parked on the elevated track at the Latrobe platform. Both of LGV's gas-electrics were manufactured by the Electro-Motive Corporation of St. Louis in 1926 for the Boston & Maine Railroad (B&M). Ligonier bought the pair from the B&M in November 1943 with the intent of replacing its steam-powered passenger trains.

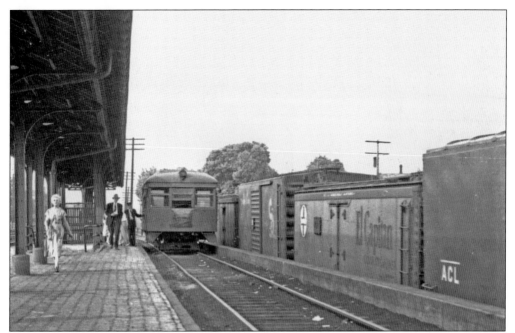

This view from the end of the Ligonier line in Latrobe was taken after 1928, when the M-10 doodlebug seen here was purchased from equipment broker M. Bennett & Sons. Conductor Denny Piper can be seen assisting disembarking passengers. With the PRR main line to the left of the passenger platform and its freight yard on the right, the Ligonier line bisected the PRR's Latrobe operation.

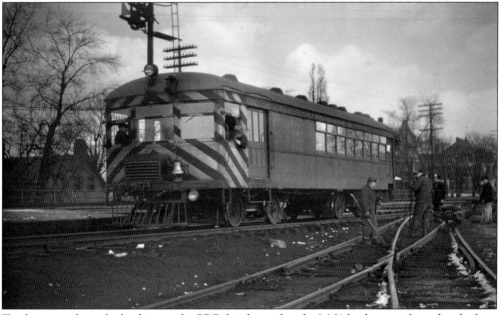

Trackmen work on the lead-ins to the PRR freight yard as the M-21 backs away from the platform toward the wye to turn around for its return trip to Ligonier. The M-21, a Model 55, was built by the J.G. Brill Company in 1929 for the St. Louis Southwestern Railroad and subsequently purchased by Ligonier in 1937.

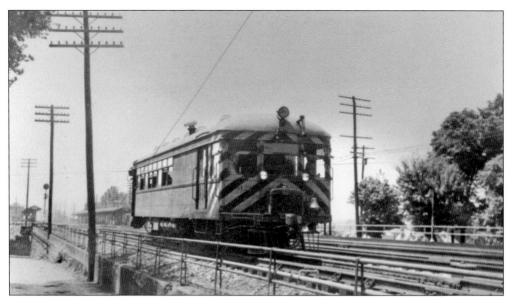

As the M-21 moves toward the Latrobe wye on its return trip to Ligonier, it passes by the site of the original LGV station in Latrobe. The station (not pictured) stood to the left, at the corner of Alexandria Street and Railroad Avenue (now Hoke Street).

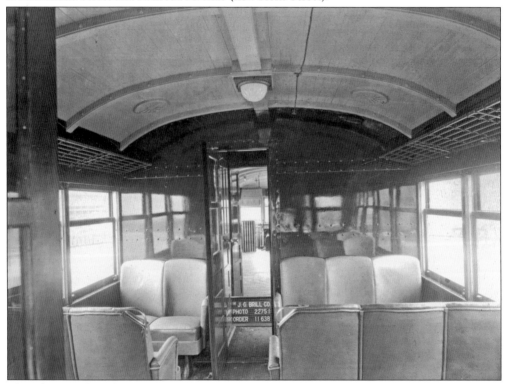

This photograph of the interior of the M-21, taken by builder J.G. Brill before delivery, shows the front of the passenger section and the corridor leading to the engineman's compartment. The areas on both sides of the corridor were used for baggage. The steel walls behind the second row of seats create a mirror image, which distorts the view.

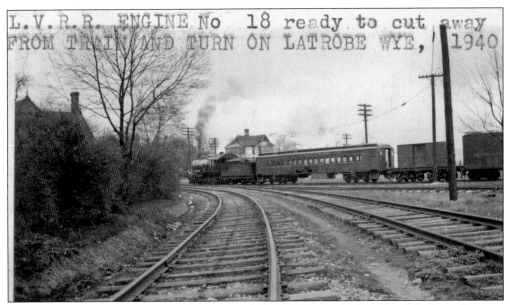

L.V.R.R. ENGINE No 18 ready to cut away FROM TRAIN AND TURN ON LATROBE WYE, 1940

The notation on the photograph above was made by Bill Smith, the founder of the Penn-Ligonier Railroad Club. The two tracks in the foreground made up the west leg of the Ligonier wye in Latrobe. The sister photograph below of the same train includes a closer view of the homemade baggage car, which was built onto the frame of No. 17's tender in the early 1930s, and shows the water plug, which delivered water into the tenders of steam engines from an underground cistern.

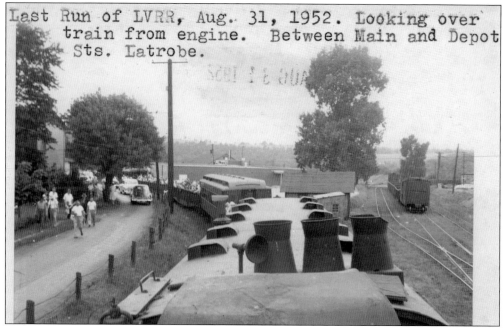

In this photograph of the Last Run, the train is on the west leg of the Latrobe wye and the standing freight cars are on the east leg, which at one time had as many as four tracks. The Last Run included three doodlebugs, coach No. 25, and three gondolas borrowed from the PRR. The roofline of the No. 1150 doodlebug is in the foreground.

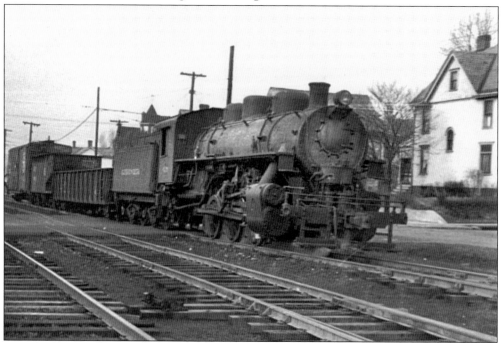

This view of No. 4025 shows the LGV tracks parallel to Latrobe's Lincoln Avenue at the Weldon Street grade crossing. No. 4025 is heading toward Ligonier with a typical freight consist that includes a gondola, a hopper, and a boxcar.

18

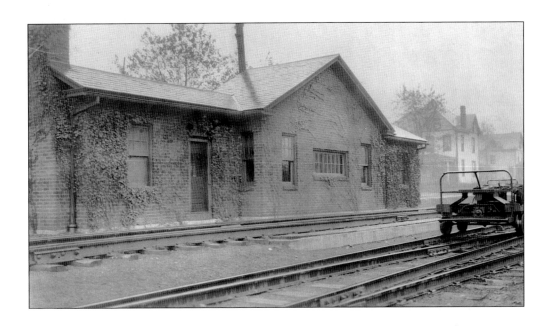

According to LGV employee Elroy Byers, the speeder in the foreground of the photograph above was powered by a flathead V-8 engine. The scale house seen in both these photographs was located on Lincoln Avenue, four blocks from the wye between Weldon and Spring Streets. It was built around 1920 to weigh all shipments of commodities, including gravel, coal, and coke.

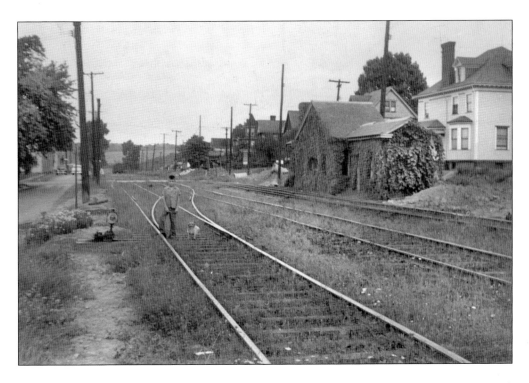

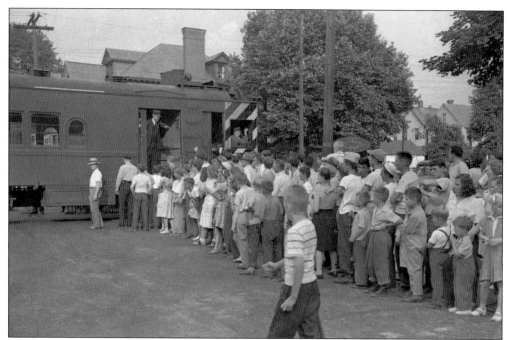

At the Weldon Street grade crossing, conductor Denny Piper welcomes a field trip of elementary students from the nearby Second Ward School. Engineer Fred Iscrupe is in the window of the doodlebug awaiting instructions. The house in the background is now the location of the Lopatich Funeral Home.

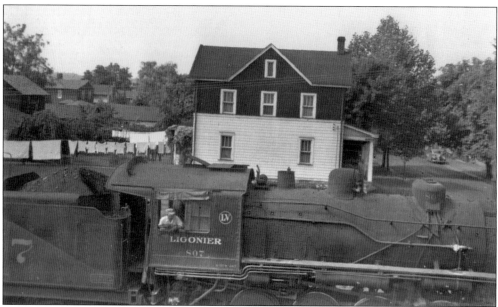

This view reveals one negative impact the railroad had on the daily lives of residents living along the line. Clothes still needed to be washed on a regular basis, regardless of the train schedule. Perhaps this homemaker relied on the prevailing westerly breeze to hang her clothes upwind from the cinder-belching locomotives. This two-tone house can still be seen at the corner of St. Clair and Truman Streets.

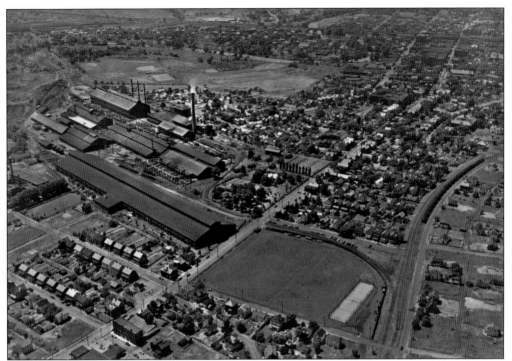

The 70-acre steel mill complex, seen in this aerial view from around 1950, was once serviced by the LGV. The roadbed of the LGV can be seen on the right, with the Cherry Street siding curving around the athletic field into the steel mill. Built in the early 1900s, the original Latrobe Steel Company has undergone numerous changes in ownership, including stints as ALCO and Standard Steel. The melt shop remains in operation today under the ownership of Lehigh Special Metals.

Viewed from the Cherry Street siding, this dual-gauge track system enabled the narrow-gauge dinkies from the steel mill to maneuver standard-gauge cars throughout the plant as well as to interchange with the LGV. In the background is Shaft No. 2 of the Loyalhanna Coal & Coke Company. (Courtesy of the Latrobe Historical Society.)

Throughout its history, the LGV owned very few freight cars, and those were almost exclusively used for online service. At the time of this photograph, around 1905, the railroad owned only two boxcars. The highest number of railcars ever recorded in use at one time was 23, in the 1910s, at the peak of the coal and coke business. (Courtesy of the Latrobe Historical Society.)

Located 1.2 miles from the Latrobe wye, the Oakville station was built in 1899 at the intersection of Harrison Avenue and Grant Street. According to the March 7, 1900, *Ligonier Echo,* the first agent at Oakville was Cummins Kimmel, an LGV track foreman. Although the station building itself was closed and sold in 1926, the LGV maintained scheduled stops at this site. The building serves as a residence today.

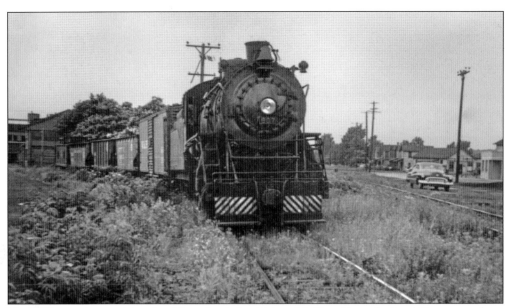

No. 807 is seen here exiting the siding that led to Vulcan Mold and Latrobe Steel Company, where Lincoln Avenue dead-ends at Hillview Avenue. Several heavy industries located their plants in south Latrobe in the early 1900s because of the proximity to LGV rail service.

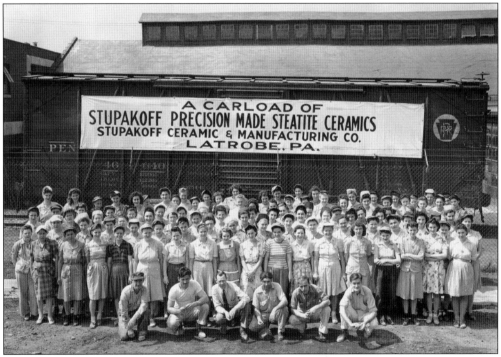

Stupakoff Ceramics moved its operation from Pittsburgh to Hillview Avenue in Latrobe in 1940, to a larger, modern plant with rail service provided by the LGV. Per its 1944 employee handbook, its "ceramic manufacturing facilities are devoted 100% to the production of 'radio grade' ceramics for the war program." The nearly all-female workforce reflects the World War II image of Rosie the Riveter.

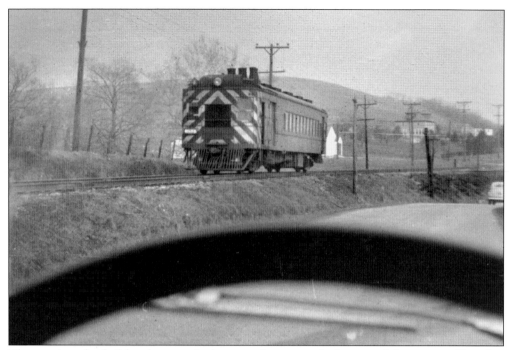

The steering wheel of the photographer's car can be seen at the bottom of this image of Latrobe-bound doodlebug No. 1152, which has just passed the Reed farm, visible in the background. Approximately five minutes from Kingston, the doodlebug is approaching the site of the former Osborne station, which was 2.1 miles from the Latrobe wye.

The photographer's car is included in this 1925 image of the grade crossing onto the Reed farm and provides a juxtaposition of the two modes of transportation between Kingston and Osborne.

Two

KILNS, QUARRIES, AND GRANDEUR

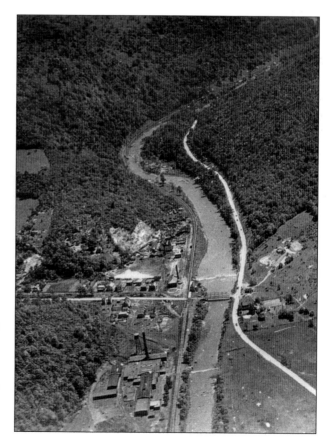

In this view of the western entrance to the Loyalhanna Gorge, Loyalhanna Creek can be seen flowing toward Latrobe, with the Lincoln Highway, today's Route 30 east, on the right and LGV's main line on the left. Along the main line are (bottom to top) the Peters Paper Company, Latrobe Water Works, and "the brickyards." Near the intersection is the Kingston station.

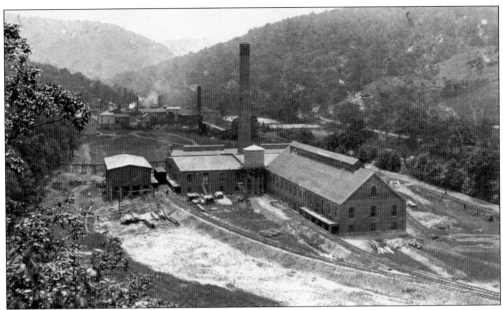

These two photographs of the Peters Paper Company show how large the factory was. A manufacturer of roofing paper, Peters moved its plant from Latrobe to Kingston in 1901 because it had outgrown its Latrobe facility and wanted to gain access to LGV's rail service. An additional incentive to relocate was the PRR's offer to absorb all freight charges levied by the LGV. James Peters, the owner of this plant, was also one of the earliest investors in the coalfield later developed along LGV's Mill Creek Branch.

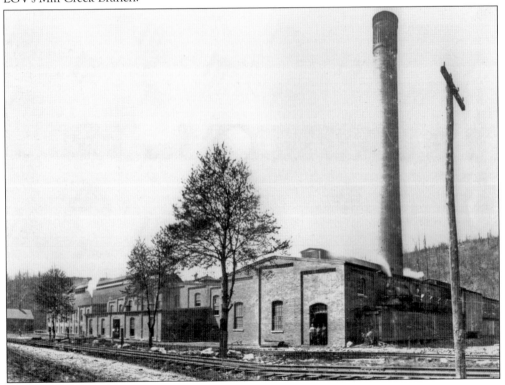

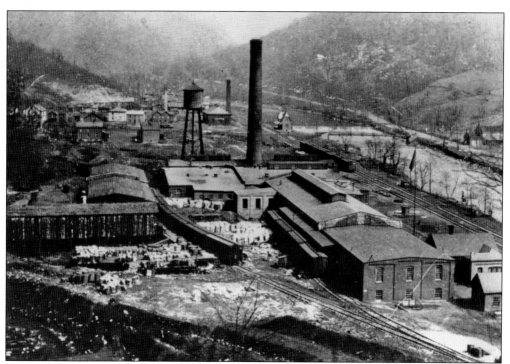

In 1913, James Peters, through a stock swap, sold the paper company to the American Coal Products Company, later known as the Barrett Company. This photograph was taken after 1916, when some major improvements and additions were made. Barrett made efforts to upgrade the plant, but it succumbed in the mid-1920s. The buildings remained vacant until the late 1930s, when Kennametal purchased the complex.

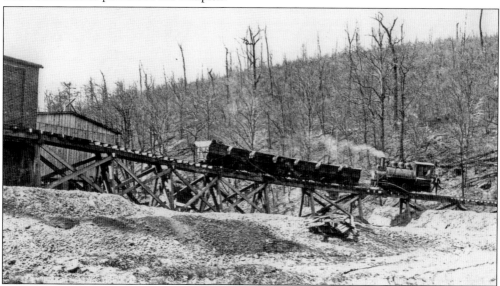

This photograph provides a view of the dinky and mine cars after the mine was reopened by Barrett in 1916. According to the December 13, 1922, issue of the *Ligonier Echo*, this dinky became the focus of attention after it caused a fire when "a spark from a dinky engine at the Barrett Paper Mill . . . destroyed a carload of felt paper and about 150 bales of rags and paper."

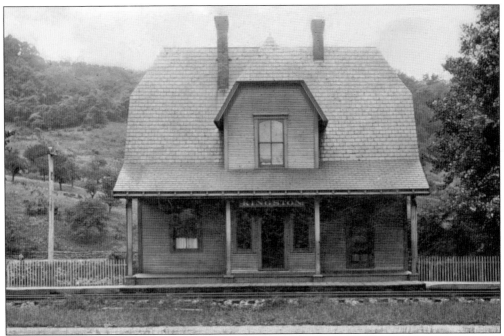

The Kingston station, located 3.2 miles from the wye in Latrobe, was one of three LGV stations that provided living quarters for the agent and his family. One room was reserved for railroad purposes and included the office and the waiting room. In 1904, stationmaster Harry Luce doubled as a superintendent at the Ligonier Silica Brick Company, across the tracks. When he was at the brick works, his "little girl ran the store."

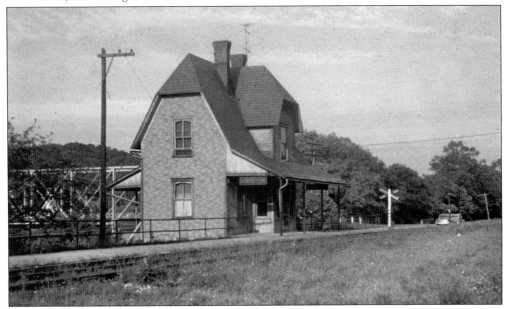

The similarity of the Kingston station to the Oakville station suggests that the railroad utilized the same set of blueprints to build both buildings. Kingston remained in service until the railroad was abandoned in 1952 and was torn down to make room for the new westbound lanes of Route 30 in the 1950s.

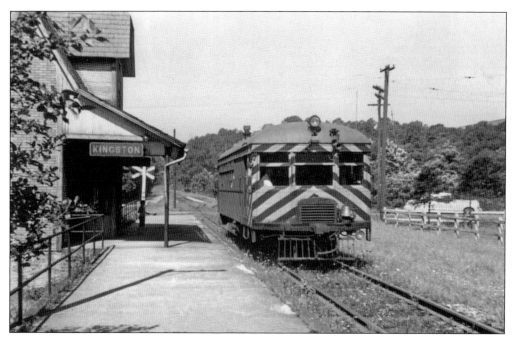

In this view of the M21 at the Kingston station, it is heading for Ligonier, some 16 minutes down the line. LGV schedules varied from year to year and season to season, offering up to five daily round-trips between Ligonier and Latrobe. Kingston was a scheduled stop on every one of those runs.

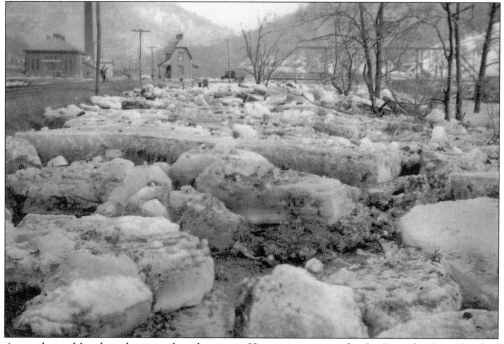

As evidenced by this photograph, taken near Kingston station, the St. Patrick's Day Flood of 1936 wreaked havoc along Loyalhanna Creek. It appears that the rail line was not impacted here, however. In the background, across the tracks from the Kingston station, stands the Latrobe Water Works.

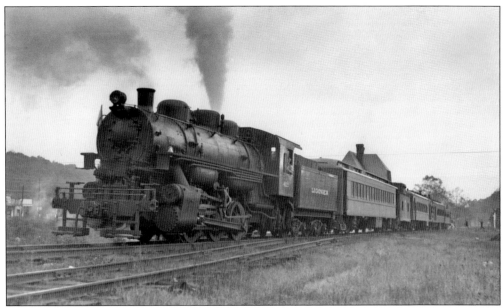

Soon after its 1948 arrival in Ligonier, No. 4025 is seen at the Kingston station leading a railfan special. Nicknamed Little Joe, the engine had an 0-6-0 wheel configuration and remained in service with the LGV until it shut down in 1952.

The hillside beyond the Kingston station was rich with ganister rock, ideal for making the bricks used to line steel mill furnaces and ovens. The William Stuart Silica Brick Company was built in 1893. It later became known as the Ligonier Silica Brick Company. LGV serviced the brick company as well as two additional brickyards built nearby later. (Courtesy of the Latrobe Historical Society.)

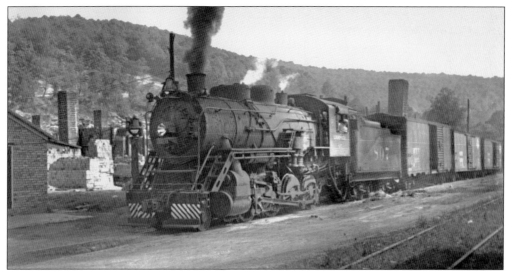

No. 807, seen here passing by the Joseph Soisson Fire Brick Company, was the second replacement engine purchased secondhand by the LGV in 1948. A Consolidation, it was built by Baldwin in 1910 for the Southern Railway. The Silica Brick Company built the second brickyard at Kingston, which was later taken over by the Joseph Soisson Fire Brick Company.

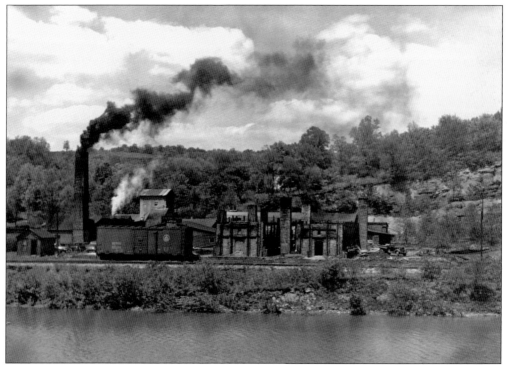

This view of the Soisson brickyard from the opposite side of Loyalhanna Creek shows the face of the ganister rock quarry. Less than a mile away toward Ligonier was a third brick plant, the Pennsylvania Silica Brick Manufacturing Company, which began operations in April 1903 and advertised itself as being located in East Kingston. The 1917 valuation drawing for the LGV lists this plant as the Keener Brick Company.

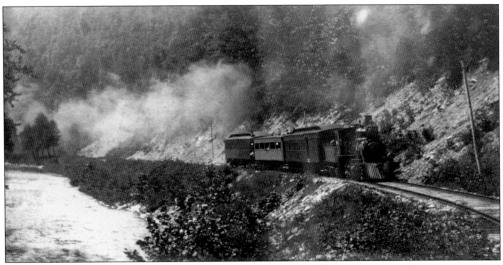

No. 6 leads a typical summer train through the scenic Loyalhanna Gorge. The open-air car in the middle was painted yellow. No. 6, a 2-6-0, was the first new locomotive purchased by LGV, costing $7,339.85. It was built in 1888 by the Baldwin Locomotive Works of Philadelphia and retired in 1912 or 1913. (Courtesy of the Ligonier Valley Historical Society.)

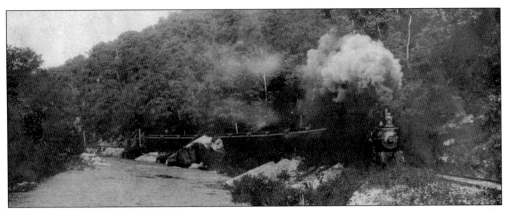

This photograph shows a typical PRR Idlewild excursion train in the Loyalhanna Gorge. Normally a picnic excursion resulted in one or two special trains, often originating in Pittsburgh, each comprised of up to 12 cars. Depending on the size of the picnic, as many as 10 PRR trains arrived at Idlewild on a single day. No mishaps were ever reported.

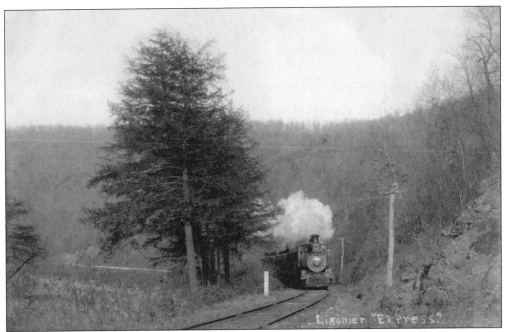

No. 10 (1) is seen in these photographs passing through the Loyalhanna Gorge, treating passengers to the most spectacular views on the LGV line. This engine, an American-type 4-4-0, was built by the Altoona Works of the PRR in 1883. LGV bought it in 1906 at a price of $3,500. Although details are unknown, it was apparently returned to the PRR and replaced by another 4-4-0 engine, No. 10 (2), in February 1910. Since No. 10 (1) was only on the LGV for a few years, photographs of it are rare. The notation "Ligonier Express" above invokes artistic license and has nothing to do with the formal Ligonier Express operation between Pittsburgh and Ligonier in the 1920s. (Both, courtesy of the Pennsylvania Room of the Ligonier Valley Library.)

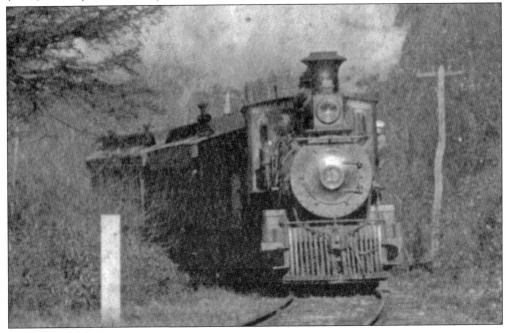

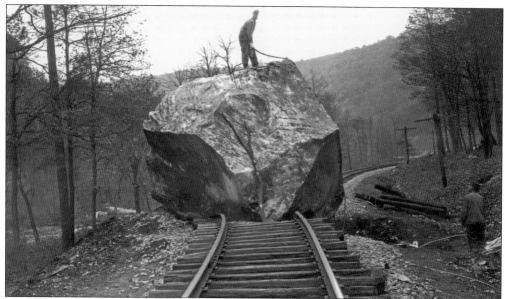

The November 1, 1922, edition of the *Ligonier Echo* reports, "A large rock tumbled down on the tracks of the Ligonier Valley R. R. at Longbridge last Thursday shortly after noon. The work of removing the rock was begun immediately and trains were running Friday as usual. The afternoon and evening trains on Thursday could not run on account of the rock." (Courtesy of the Ligonier Valley Historical Society.)

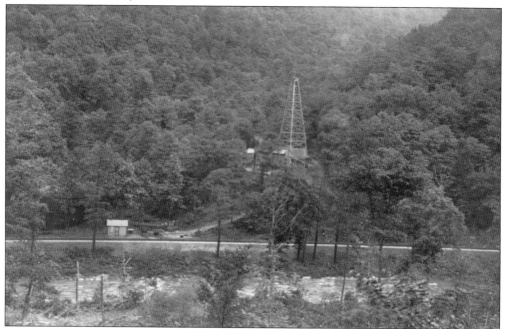

According to 1923 issues of the *Ligonier Echo*, Peoples Natural Gas drilled three gas wells in the Loyalhanna Gorge. The first one, near McCance, was successful and 6,822 feet deep. However, the second well, seen here on the hillside above the railroad, was declared a "dry hole" at a depth of 6,850 feet. Even though it failed, LGV profited from the venture by transporting 100 tons of casing pipe to Peoples Natural Gas at the drilling site.

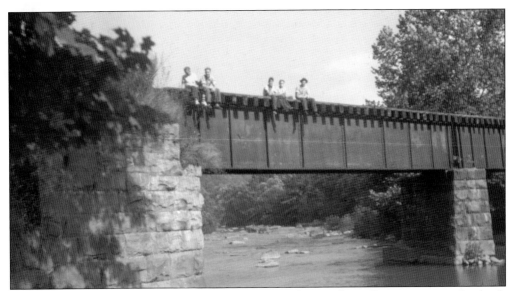

This bridge was built in 1892 for the exclusive use of the Booth & Flinn quarry, on the south wall of the Loyalhanna Gorge, which was one of several quarries located in the gorge. The deck plate–girder bridge included two 50-foot spans, requiring a pier in the middle of the creek. Although the pier has fallen, it and both abutments remain visible today. In this mid-1950s view, Boy Scouts sit on the bridge during a hike.

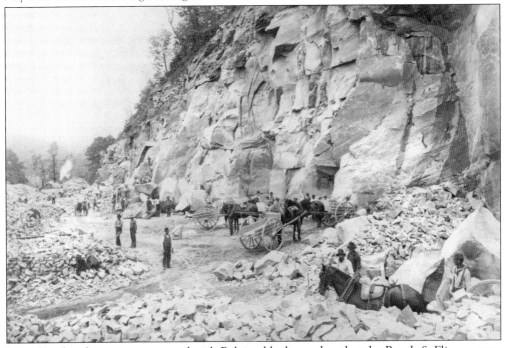

Many Pittsburgh streets were paved with Belgian blocks produced at the Booth & Flinn quarry, on the south wall of the gorge, and transported to the PRR in Latrobe by the LGV. Once the face of the quarry was drilled and blasted, the resulting piles of rock were then hammered and chiseled into the desired block size. The remaining debris was crushed, sorted by size, and sold as ballast, macadam, or gravel.

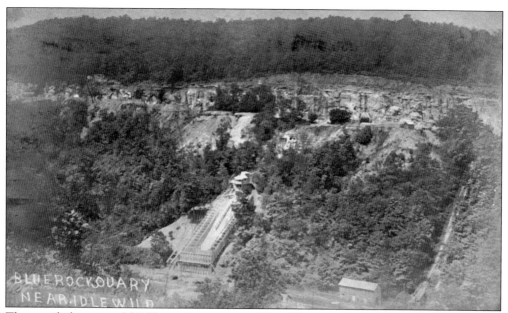

The specific location of this blue rock quarry near Idlewild is unknown. Although the larger-than-usual tipple seen here serviced the blue rock quarry, local historians disagree as to whether or not this tipple stood on the north or south wall of the gorge. Arguably, the track at the base of the tipple could be the LGV main line on the north wall, or the Baker Siding on the south wall.

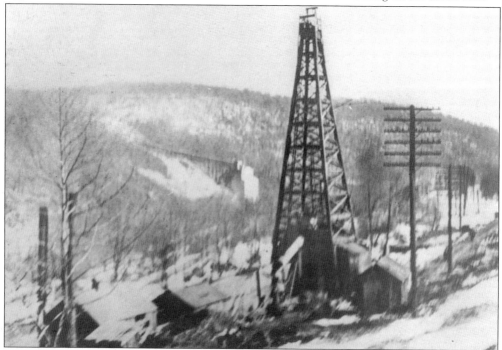

The tipple in the background of this photograph is the same tipple that was last used in 1952 to load hopper cars with gravel from the quarry on the north wall of the Loyalhanna Gorge. Some people speculate that this tipple was the second tipple on the north wall and was located adjacent to the site of the much larger tipple seen in the previous photograph.

This view of the quarry tipple on the north wall is facing Ligonier. The entire quarrying operation gradually moved to the north wall after a better quality of blue rock was located. The grade carved from the hillside along Loyalhanna Creek through the gorge on which the tracks in the foreground lay is the same grade that the westbound lanes of Route 30 follow today.

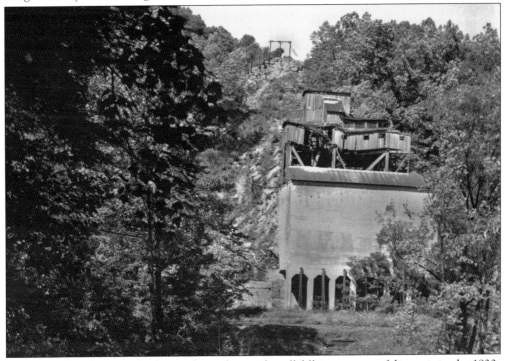

As seen in this photograph, the tipple on the north wall fell into a state of disrepair in the 1930s and 1940s, when it was no longer used to load railroad cars. By this time, trucks were loading at the quarry site and delivering orders directly to customers.

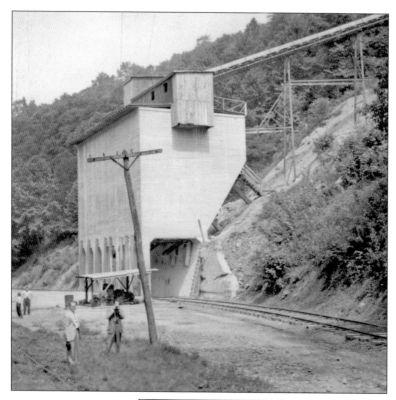

Another view of the north-wall tipple, this was taken around 1950, after it was upgraded for one last job: the construction of a flood-control dam on the Connemaugh River near Saltsburg. More than 447,000 tons of gravel were shipped over the Ligonier line between 1949 and 1951, when the dam was built. (Courtesy of the Pennsylvania Room of the Ligonier Valley Library.)

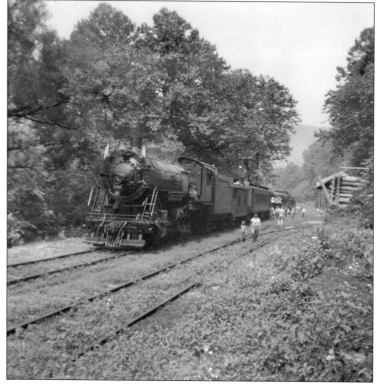

The Penn-Ligonier Railroad Club of Latrobe organized five railfan specials over the LGV line from 1948 to 1952. A stop at the quarry tipple in the Loyalhanna Gorge was included on these specials to enable photographers the opportunity to capture the event. In the right foreground is the track that led to the tipple in the previous photograph.

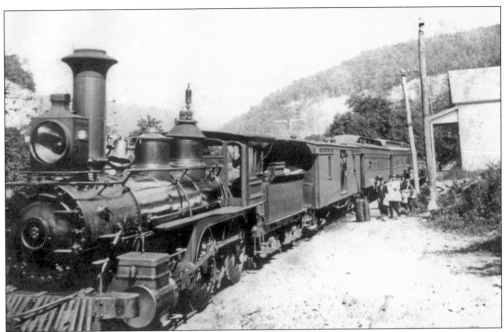

This is the only known photograph of No. 8 and, coincidently, the only known photograph of the Longbridge station, a one-room building that doubled as a convenience store. The engine, an 1869 product of the Altoona Works of the PRR, was sold to the LGV in 1893 for $1,500 and remained on the roster until 1912 or 1913. One of the four engines named by the LGV, she was dubbed *Ligonier*.

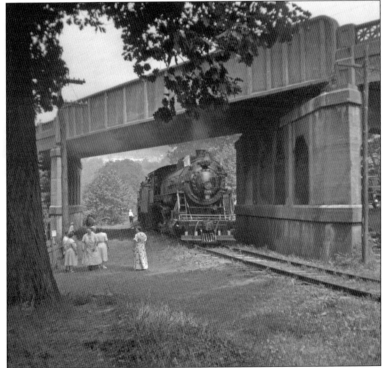

During the June 1952 railfan special, No. 594 pauses under Longbridge for a photograph after unloading its passengers. During the break, some of the female railfans socialize while others appreciate the opportunity to take photographs and enjoy the scenery.

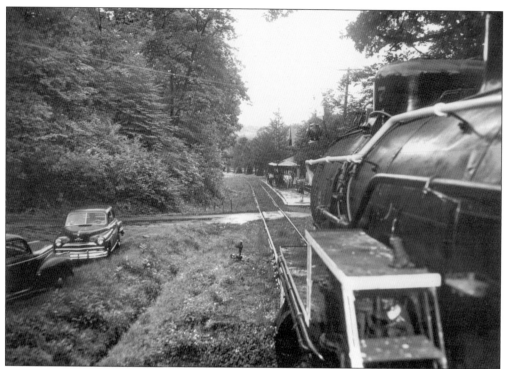

In this view, taken from the fireman's window of No. 807 during the Last Run on August 31, 1952, the Darlington station and a cluster of people awaiting the train can be seen beyond the grade crossing at Idlewild Hill Road. (Courtesy of the Ligonier Valley Historical Society.)

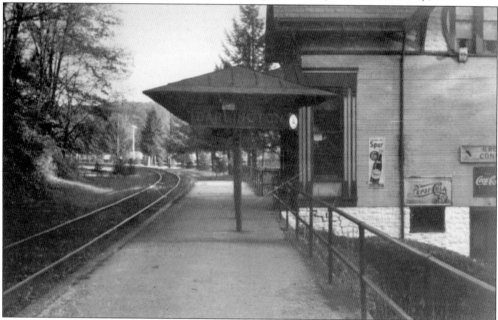

This view of the Darlington station, located 7.2 miles from the wye in Latrobe, shows the passenger shelter attached to the building and the station's extensive concrete platform. Just beyond the platform is Idlewild Park.

Three

IDLEWILD AND ICE

Idlewild Park was conceived by Judge Thomas Mellon to increase ridership on the LGV. As seen in this flyer, Ligonier promoted the park while LGV offered special trains to Idlewild from all points along its line, including the Mill Creek Branch. From its inception in 1878, the park has been a destination for families, church groups, social lodges, and workplace and community outings. Idlewild Park continues to be one of Ligonier's premier attractions today.

LIGONIER VALLEY
REUNION
Thirty-Eighth Annual

LIGONIER VALLEY PEOPLE

will hold the Thirty-Eighth Annual Reunion and Basket Picnic of Ligonier Valley at

IDLEWILD PARK
THURSDAY, AUGUST 15, 1929

Every man, woman, boy and girl of this great and popular Ligonier Valley lying between the Chestnut Ridge on the west and the Laurel Mountain on the east, stretching beyond Donegal on the south and to the river on the north, and the friends of the valley people wherever they are in Pennsylvania, the United States and the whole wide world, are cordially invited to this greatest and most enjoyable of great reunions. "Lest you forget," tell your friends about it, send them invitations and come yourself. Take this one day for enjoyment and pleasure at our own beautiful Idlewild.

Sociability, friendship and good cheer make these reunions famous. Dancing, with a fine orchestra, baseball game with the Homestead Grays, athletics and other sources of amusement. Ligonier Valley Reunion is the great day for the people of this section. If you haven't been to a picnic this season go to Idlewild August 15th. It will do you good.

The committees are making preparations to make this day one of happiness and pleasure. It is the desire of all valley people to make every annual reunion the best and largest possible. With the usual large attendance, well filled baskets for dinner and good cheer, everybody will be glad for being present.

Schedules of trains on the L. V. R. R., program and other information and large bills and publication in the Ligonier Echo will give all desired information.

Committee of Arrangements:
J. B. SINGER, President.
J. W. CLOPP, Secretary.

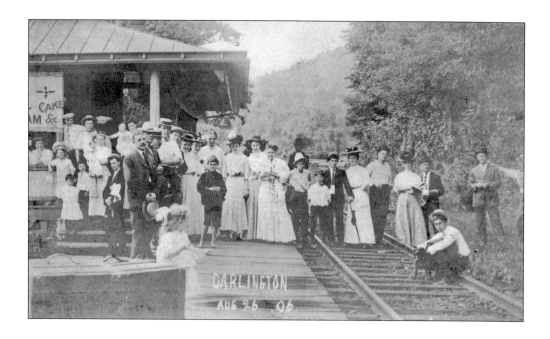

The Darlington station was located on the Latrobe side of Idlewild Park. In these views of the station, the photographer was facing Latrobe. Darlington station, built in 1896, stood out from the other stations because of its Victorian architectural style. As at Oakville and Kingston, railroad business was conducted in one room only, while the stationmaster lived in the remainder of the building. In Darlington's case, the station also featured the park store, where passengers could buy lunches for their picnics at Idlewild.

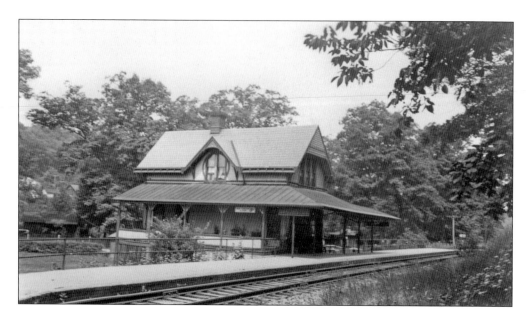

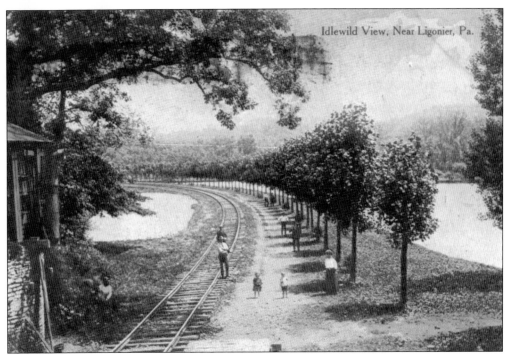

These two views of the railroad entrance into Idlewild Park capture the beauty of two of the three man-made lakes that Idlewild visitors enjoyed. Above, Lake St. Clair is on the left, Lake Bouquet is on the right, and the structure on the left is the water tower used by the railroad. Below, a steam engine pulls a summer train into the park. Rather than the amusement park that Idlewild is today, it was originally a picnic grove that advertised clean air and fresh water to entice guests from the smoky city of Pittsburgh. Picnic attire was much more formal in those days, with both women and men wearing their Sunday best.

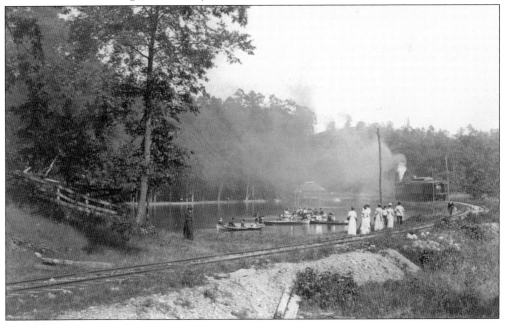

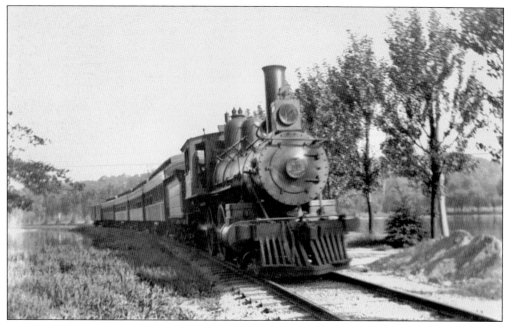

Pulling four coaches and a baggage car, No. 10 (2) departs Idlewild and approaches the Darlington station. This engine was built in Altoona in 1888 and sold to Ligonier in 1910 for $4,500. Although details of the transaction remain unclear, this engine replaced No. 10 (1) on the roster of LGV equipment. No. 10 (2) was slightly damaged in the 1912 wreck.

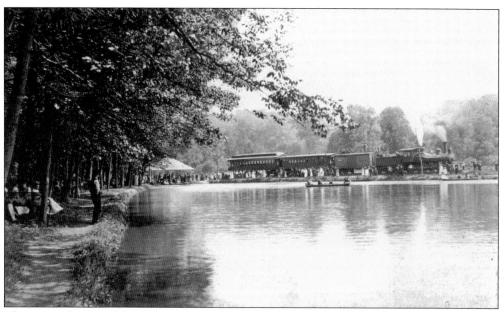

This tranquil scene of No. 7 passing through Idlewild Park and hauling a passenger consist creates a nostalgic picture of the past, with Lake St. Clair in the foreground and a shaded picnic grove to the left. The 4-6-0 engine was purchased new from Baldwin in 1889 and named *R.B. Mellon*. No. 7 was one of the two freight engines destroyed in the 1912 accident near Wilpen.

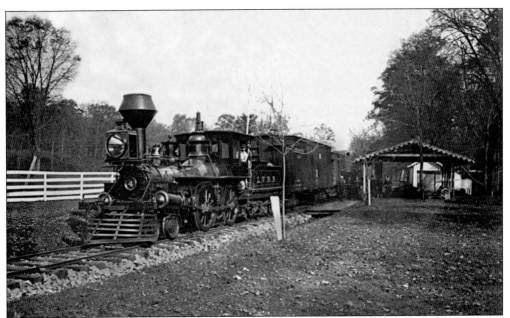

No. 4, a 4-4-0 American-type locomotive, was the first standard-gauge locomotive purchased by Ligonier. Although its exact pedigree is unknown, it dates from the 1850s and was purchased in 1882. Headed for Latrobe, No. 4 is seen here at the Idlewild station, which was located on the creek side of the tracks at that time. In 1885, No. 4 collided with a cow, causing enough damage that it had to be repaired in Altoona.

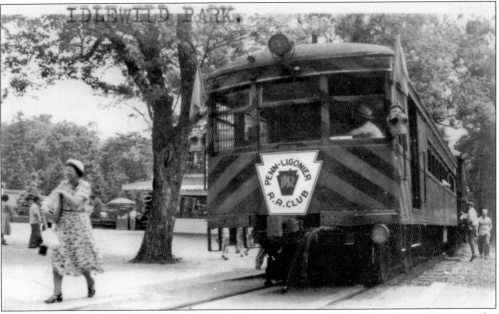

When established in 1878, Idlewild Park, for the most part, was limited to the area between the railroad tracks and Loyalhanna Creek. The park experienced several expansions over the years, encompassing both sides of the tracks and the opposite side of the creek. In this photograph from around 1948, the creek is to the right (out of view). The building behind the tree was the two-story station, built in 1931.

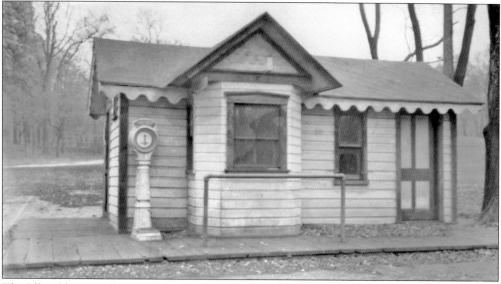

The Idlewild station, located 7.6 miles from the Latrobe wye, was manned throughout Idlewild's summer season. Its scalloped fascia is a distinctive design feature on LGV structures. When the station was replaced by a two-story building in 1931, the original building continued to serve Idlewild Park in various capacities, including as a first aid station in the 1940s, and, most recently, as a guest relations facility and a museum dedicated to the origins of the station and Idlewild Park. Below, Bob Householder, the oldest retired employee of the LGV, is honored during the Last Run festivities by receiving the last ticket issued from the Idlewild station.

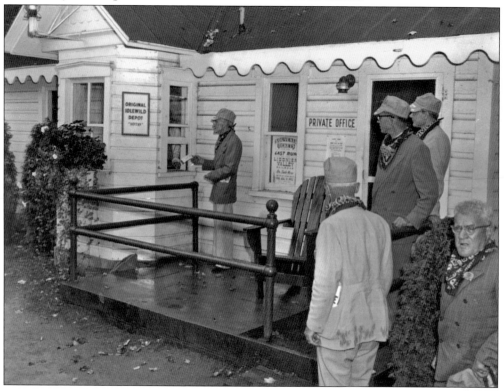

This 1895 Smithfield Concordia invitation is representative of numerous invitations extended by associations, churches, lodges, and companies that sponsored annual picnics at Idlewild Park in the 1890s. The cooperation between the PRR and the LGV to promote Idlewild Park benefited all three entities.

The PRR was an active promoter of Idlewild from the time of its creation in 1878. The total number of PRR excursion trains to Idlewild over the years easily numbered in the thousands. The three tickets below, issued by the LGV to stations on the PRR, illustrate the extent of cooperation between the two railroads.

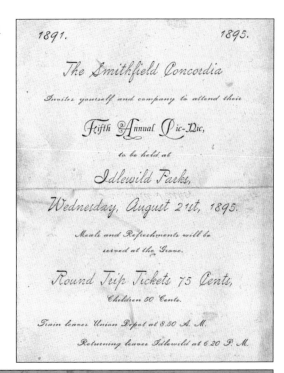

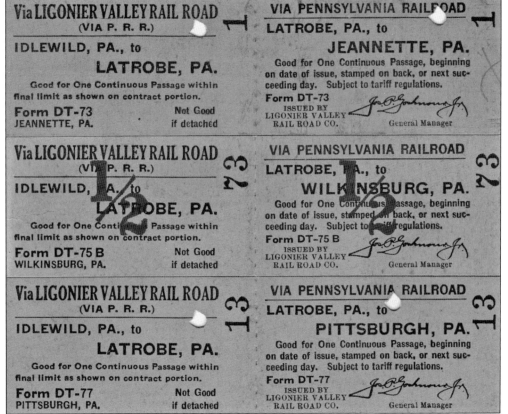

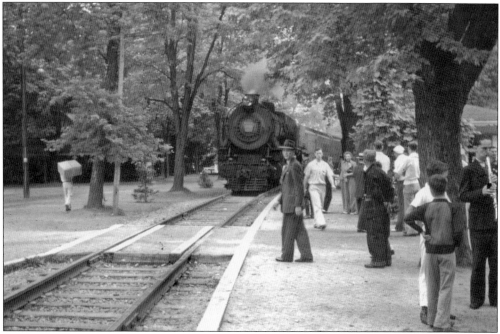

When Idlewild was first opened, the LGV track formed one of the park boundaries. After the park expansion in the 1890s, the railroad ran directly through the middle of the grounds, and anyone arriving by rail detrained in the very heart of Idlewild. This convenience to the passengers was a hazard to the conductor and the engineer, who had to worry about the safety of everyone near the railroad. Above, No. 3888, one of PRR's famed class-K4 Pacific locomotives, designed for fast main line running, moves at a much slower speed through the park. Below, passengers are shown getting off the same train. (Both, courtesy of Idlewild and Soak Zone.)

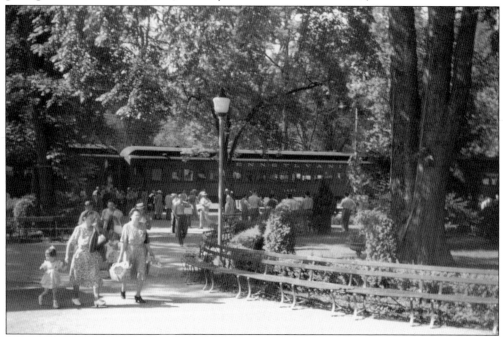

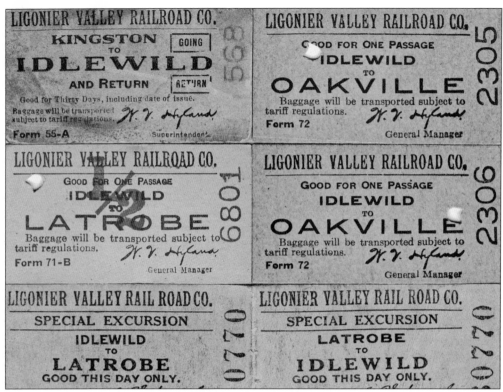

The LVRR aggressively promoted Idlewild Park as the place to be, especially for residents along the Ligonier line, as evidenced by the tickets seen here. The *Ligonier Echo* announced upcoming events, such as the annual Ligonier Valley Reunion Day, and listed LGV's special trains, schedules, and stops, including those along the Mill Creek Branch.

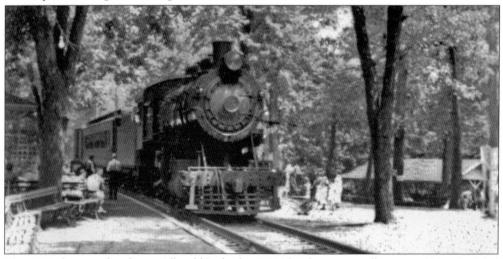

This 1937 photograph, taken in Idlewild Park of an LGV freight engine pulling a regularly scheduled Latrobe-bound passenger train, is unusual. After the doodlebug era began in 1928, doodlebugs were primarily responsible for transporting passengers between Ligonier and Latrobe. The train consists of an unidentified Baldwin Consolidation (either No. 12 or No. 15), coach No. 25, and homemade baggage car No. 27.

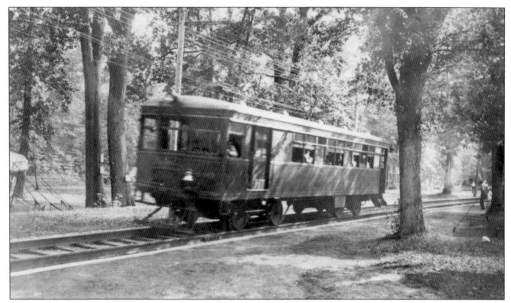

The M-10 doodlebug is seen here in regular service, passing through Idlewild Park. The roadbed through the park was well defined, with curbs on both sides of the tracks. There were no reported pedestrian accidents in the park throughout LGV's 75 years of service.

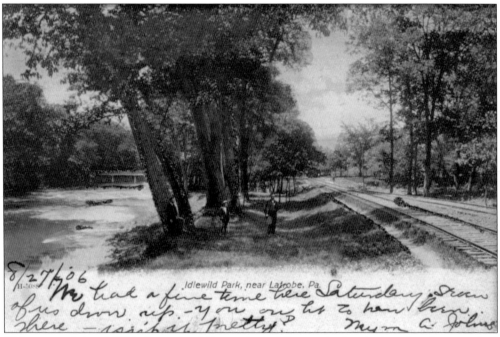

This postcard, dated 1906, shows the siding to the holding tracks for picnic trains that stretched between Idlewild Park and the Millbank station. The normal procedure was to leave the excursion coaches on one of the holding tracks while the engine continued to Ligonier to be serviced and turned in preparation for the late-afternoon or early-evening departure.

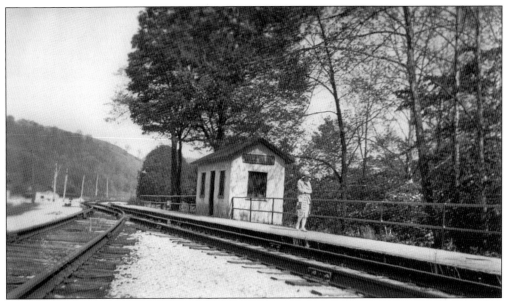

The Millbank station, located eight miles from the Latrobe wye, was a simple brick shelter with a bench inside on the back wall. The siding to the Idlewild holding tracks rejoined the LGV main line at Millbank and is visible on the left. Today, the entrance plaza to Idlewild Park is located where the picnic trains were once parked. Gladys Newlin, Hadley Martin's sister-in-law, is seen here waiting for the next train.

In the lower right corner of this photograph stand the storage tanks for the Crescent Pipeline pumping station. Originating near Pittsburgh, the pipeline required a pumping station to help move petroleum products to Philadelphia. Just beyond the larger cylinder are the pumping station and, to the left of it, the LGV track and water tub.

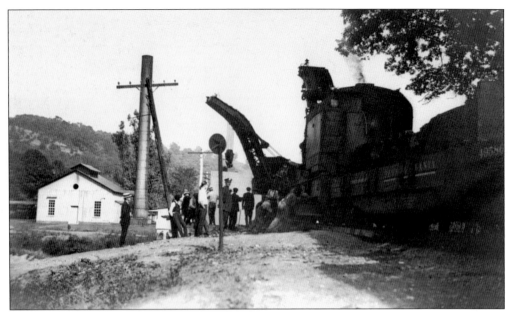

In August 1923, the railroad replaced the iron-girder bridge spanning Coal Pit Run at Millbank. Two PRR wreck trains, each including a steam derrick, were brought to the site to perform the work. One came from Derry and the other from Youngwood. To minimize the inconvenience to passengers, the work was carried out on a Sunday. To maintain the schedule, LGV staged a train on the Latrobe side of the worksite to pick up passengers from Ligonier, who walked around the bridge to board. By Monday morning, the work was complete and the railroad was back in full service. The pumping station for the Crescent Pipeline is seen to the left in the photograph above, and the Millbank water tower is visible to the left in the photograph below. This bridge remains in service today for automobiles entering Idlewild Park from the east. (Both, courtesy of the Ligonier Valley Historical Society.)

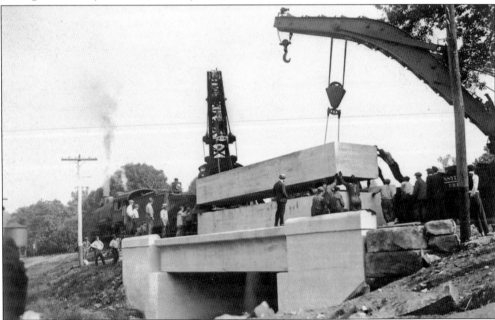

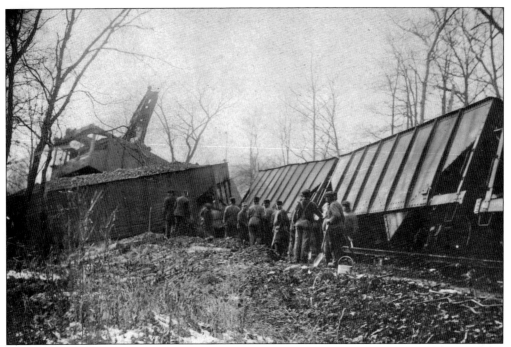

This wreck took place on Friday morning, December 6, 1907, at one of the switches to the holding tracks between Millbank and Idlewild Park. A broken frog in the switch threw the engine and six cars off the track. PRR's Derry wreck crew was summoned to clean up the aftermath, and the railroad was back in full service on Saturday morning.

In this photograph, Lincoln Highway was still a two-lane road. Today, this section carries the westbound lanes of Route 30, while the eastbound lanes of the Route 30 follow the old railroad grade on the left. The dirt road to the left leads to Bells station, 8.9 miles from the Latrobe wye. Beyond the railroad on the left is the ice pond, excavated by Booth & Flinn in 1888.

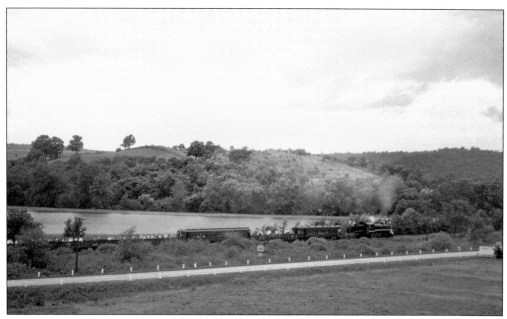

The 30-acre ice pond is seen in this photograph, taken during the Last Run. The February 13, 1888, edition of the *Ligonier Echo* comments on the importance of the ice pond operation: "This work gives employment to 400 men as the work goes on night and day. The ice averages 9 to 10 inches thick and 138 tons is put up every hour."

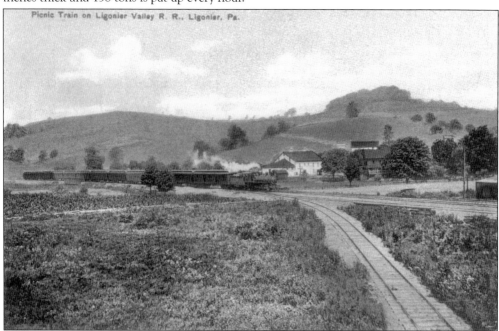

Picnic Train on Ligonier Valley R. R., Ligonier, Pa.

This picnic train is just minutes away from the Ligonier station as it passes the spur line to the South Ligonier Coal Company tipple. The company's mine was located on the opposite side of Loyalhanna Creek, near today's swinging bridge, and required a tramway to deliver the coal across the creek to the tipple. The South Ligonier Coal Company was a relatively small and short-lived concern, operating from around 1911 to around 1920.

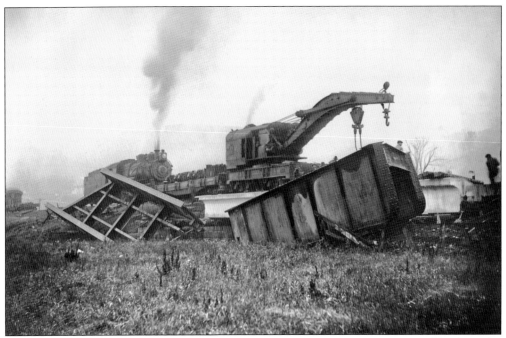

Some four weeks after the LGV replaced the bridge spanning Coal Pit Run at Millbank, it also replaced the longer bridge at Mill Creek, just west of the Ligonier station. The 83-foot iron bridge dated from the 1890s. Due to the length, the replacement bridge required a pier in the middle of the creek to support the load. As was the case at Millbank, two PRR wreck crews used derricks to complete the work on a Sunday. Because of the bridge's proximity to the Ligonier station, taxis transported passengers to the other side of the bridge to board waiting trains. (Both, courtesy of the Ligonier Valley Historical Society.)

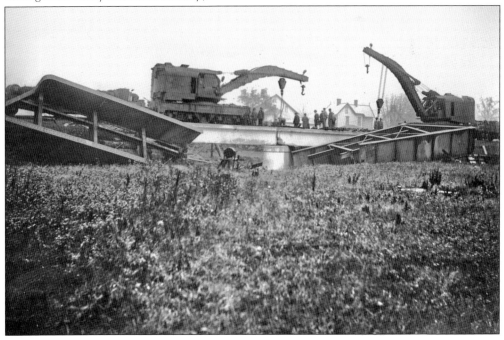

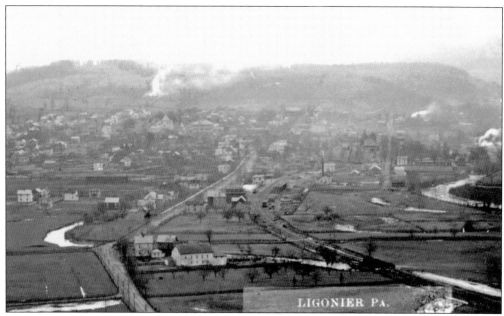

In this pre-1908 postcard view of Ligonier, Lincoln Highway, on the left, parallels the railroad track, on the right, at the western entrance to Ligonier. The original Ligonier station is the white building with windows to the left of the track in the center of the photograph.

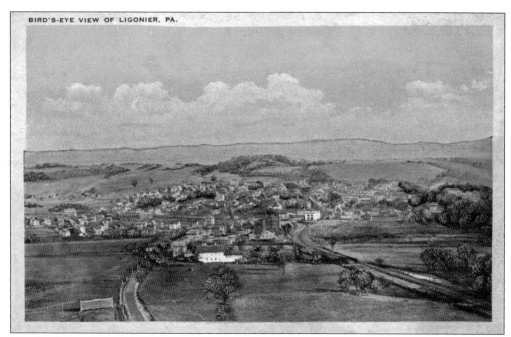

This bird's-eye postcard view of Ligonier includes the 1910 white granite station building (right of center) and the five-bay engine house (left), built in 1922.

Four

THE HEART OF THE RAILROAD

In this valuation drawing of the Ligonier wye, the heart of the LGV, the track leading to Latrobe is on the left, while the track on the lower right goes to the Byers-Allen sawmill and the connection with the Pittsburg, Westmoreland & Somerset. The tracks toward the top of the drawing show the beginning of the Mill Creek Branch. The freight station, car shop, engine house, and service facilities are all concentrated near the wye.

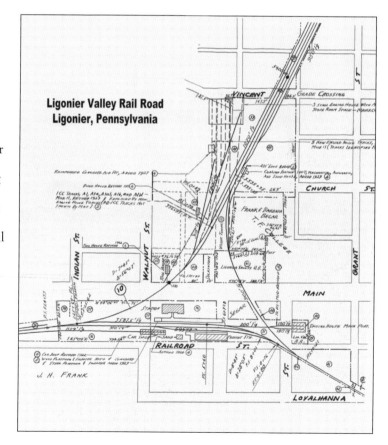

Ligonier Valley Rail Road
Ligonier, Pennsylvania

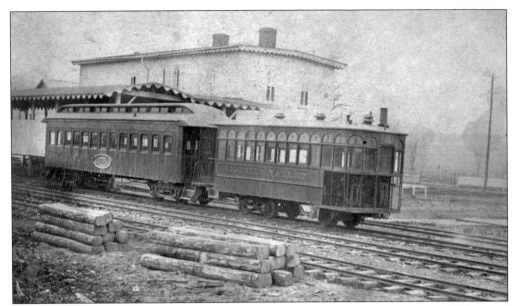

This narrow-gauge steam dummy was built by Grice & Long. The LGV purchased the used locomotive from the Pittsburgh, Oakland & East Liberty in 1881. Judge Mellon acquired this quiet-running engine hoping to placate critics of the railroad's Sunday operation. The history of the trailing coach is unknown. In the background is the original Ligonier station and passenger platform, with the distinctive scalloped fascia common to early LGV structures. (Courtesy of the Ligonier Valley Historical Society.)

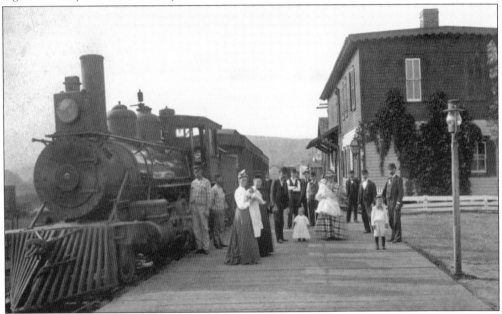

No. 6, the *Idlewild*, was one of four engines on the LGV roster that were given names. In this photograph of the Ligonier station, the passenger shelter dating from the narrow-gauge era (1877–1882) has been removed and the station is being painted. During its entire 75-year history, the LGV had only three general managers. The first one, George Senft, who served from 1881 to 1913, is the third man from the right in this photograph.

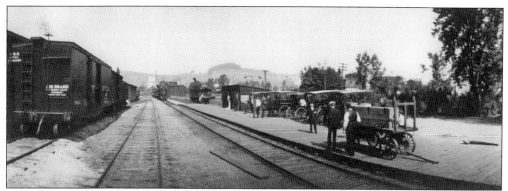

In this view from around 1908, the original station building has been moved from the right side of the tracks to the left side (out of view), where it later became the freight station. The new station, built in the area to the right of the temporary shelter seen here just beyond the buggies, was completed in 1910. Hotel hacks await the passenger train's arrival from Latrobe. (Courtesy of the Ligonier Valley Historical Society.)

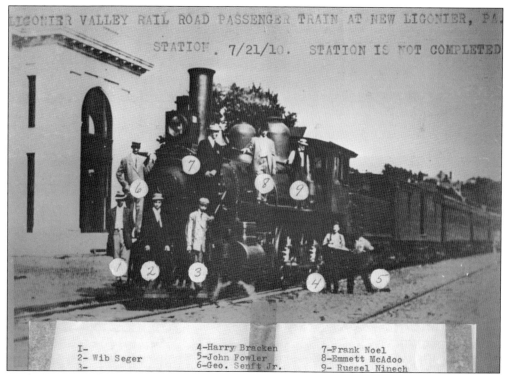

With the unfinished Ligonier station in the background, the management and staff take an opportunity to pose for a photograph on No. 10 (2). George Senft, Frank Noel, and Russel Minnich (not Ninech, as shown) were involved in the circumstances leading to the July 5, 1912, wreck.

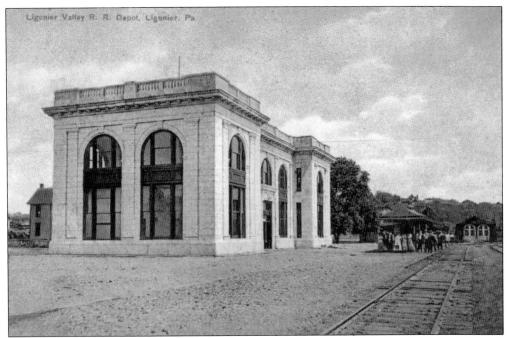

With Ligonier in the background, this postcard from around 1910 shows the track side of the new station before the grounds were landscaped. The impressive building, which cost more than $50,000 to build, remains one of Ligonier's landmarks. To the right of the station, passengers crowd together around the new shelter. Farther to the right is the original two-bay engine house.

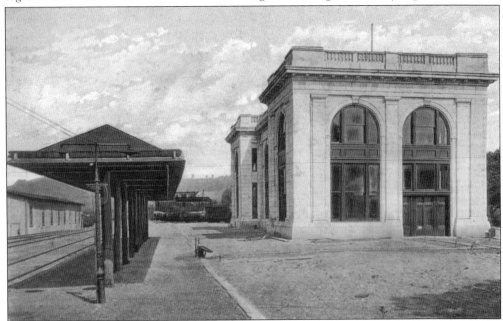

This view of the station and the new passenger platform faces Latrobe. Construction details of the station are unconfirmed, but a popular technique in 1910 was to use solid granite blocks on the lower tiers of a building and granite-impregnated terra-cotta blocks, which were lighter in weight, on the top. Some local historians believe this technique was used to build the Ligonier station.

Only three general managers were employed by the LGV; two of them are seen in this photograph. William V. Hyland (right) served as general manager from 1913 to 1926. The Hyland era was marked by the modernization of both procedures and infrastructure. Joseph P. Gochnour Jr. (left) replaced Hyland in 1926 and served as general manager until the railroad was abandoned in 1952.

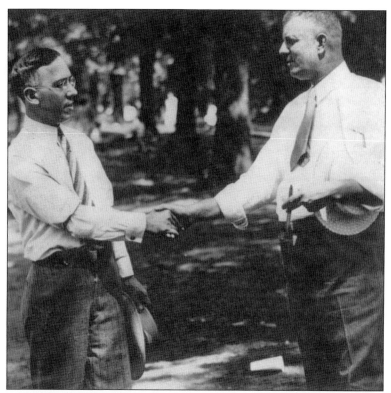

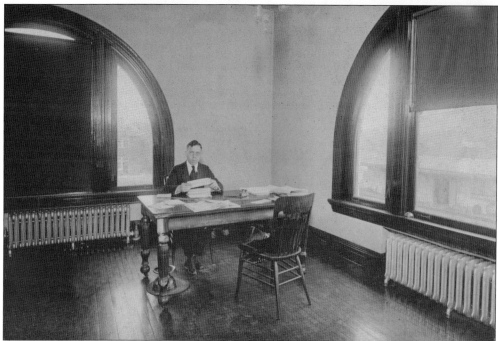

Despite the impressive appearance of the new Ligonier station on the outside, this view of the office of general manager Joseph P. Gochnour Jr. conveys its spartan interior appearance. The curved windows are a distinctive feature of the building.

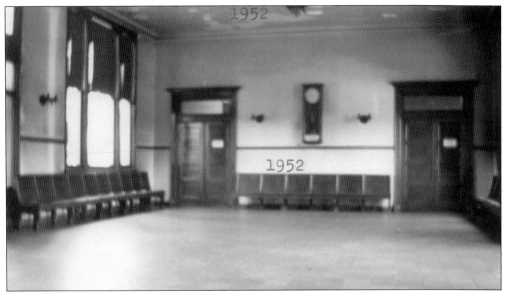

In contrast to the building exterior, the lobby of the station was unpretentious. The tracks are to the left in this photograph. Today, the doors in the photograph lead to the boardroom of the Ligonier Valley School District administration building.

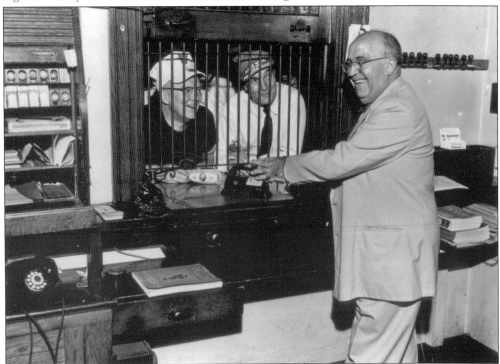

Milton Geeting began his career with the LGV in 1916 as a brakeman. Despite severe injuries received in a coupling accident in 1920, he worked for the railroad until its end in 1952. Here, in his capacity as honorary ticket agent, he validates a Last Run ticket for Bill Smith (left), the founder of the Penn Ligonier Railroad Club, as C.C. "Jack" Macdonald, the chairman of the Last Run Committee, looks on. (Courtesy of the Ligonier Valley Historical Society.)

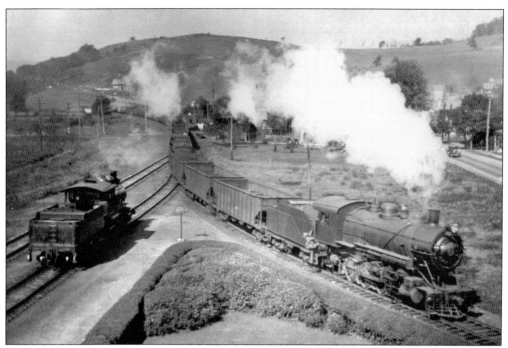

In this 1919 view, No. 17 waits on the left while a train of empties from the PRR interchange in Latrobe rounds the wye. Engineer Ted Demmitt is seen receiving train orders for a run on the Mill Creek Branch. Even though the engine's exact identity is unknown, it is one of the first three Baldwin Consolidations that the LGV purchased new specifically for the transportation of coal and coke.

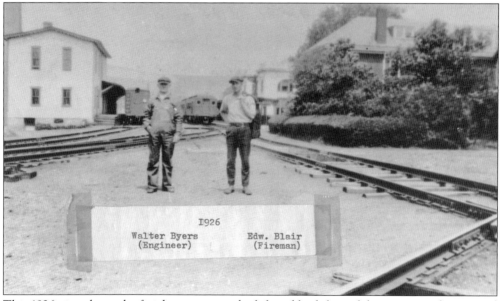

This 1926 view shows the freight station on the left and both legs of the wye extending toward Market Street. The pair of tracks on the left continue to Latrobe, and the track in the lower right corner continues to Wilpen. The track beside Edward Blair leads to the original engine house. Behind the men are the two steel coaches that LGV purchased in 1923.

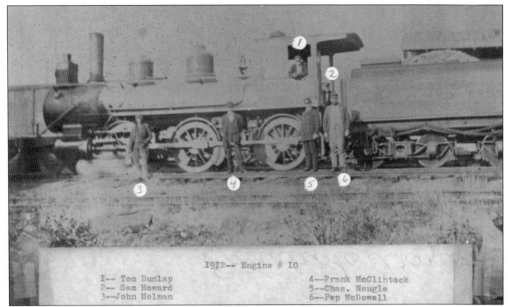

1912-- Engine # 10

1-- Tom Dunlap
2-- Sam Howard
3--John Holman

4--Frank McClintock
5--Chas. Naugle
6--Pep McDowell

Erroneously labeled as No. 10, this photograph actually shows No. 6 and its crew. Engineer Tom Dunlap began his Ligonier Valley career on December 8, 1879. Conductor Charles Naugle came aboard just five months later, on April 1, 1880. Both were veteran employees when this photograph was taken in 1912. John Holman, a young man in this photograph, eventually retired in 1952 after a 45-year career.

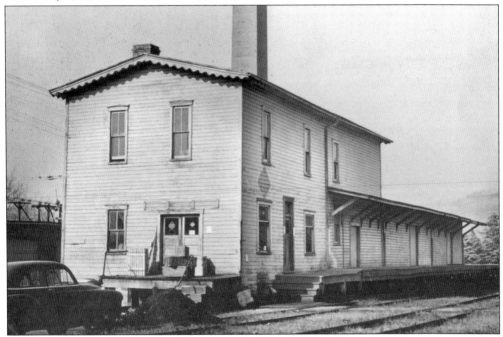

This view of the freight station shows the addition of double doors cut in the left face of the depot to accommodate larger packages. The diamond-shaped logo of the Railway Express Agency is visible on the windows of those doors as well as above the window on the side of the building facing the platform.

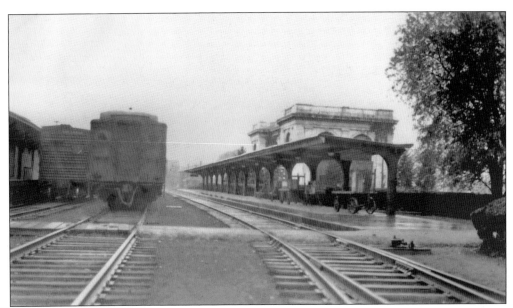

The concrete and steel passenger platform to the right of the tracks was one of the many improvements made by general manager William Hyland in 1923. Still in use today, it is now a carport for employees who work at the Ligonier Valley School District's administration building. Coach No. 25, seen here, was built by Standard Car to PRR specifications and included "owl eye" windows on both ends. (Courtesy of the Ligonier Valley Historical Society.)

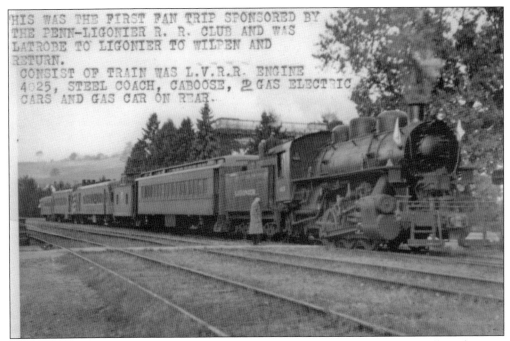

Although No. 4025 was designed for switching duty in rail yards, it is seen here pulling the 1948 railfan trip. All LGV engines were utilized in any capacity—be it switching, freight, or passenger duty—as the need arose.

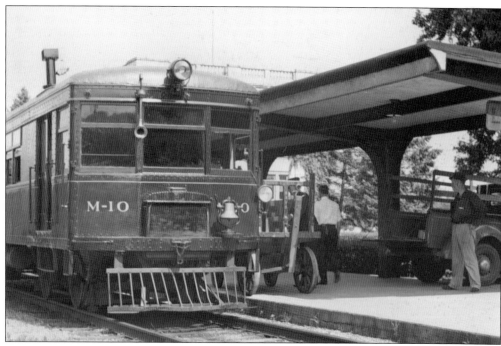

The M-10 doodlebug, seen above at Ligonier, was purchased in 1928 to reduce the costs associated with passenger service. This gasoline-powered doodlebug was a Model 55 built by the J.G. Brill Company in 1924 for the Punxsutawney Coal Company. In the photograph below, the M-10 has backed up to the site of the original engine house to take on fuel. The lean-to portion of that engine house continued to be used for storage after the engine house was torn down in 1927. After LGV sold the property in 1952, the lean-to served as a garage, a bicycle shop, a video store, and, after much renovation, a residence. According to employee Elroy Byers, M-10's engine was troublesome and tough to keep running. As a result, its engine was eventually pulled and the M-10 was relegated to permanent trailer mode.

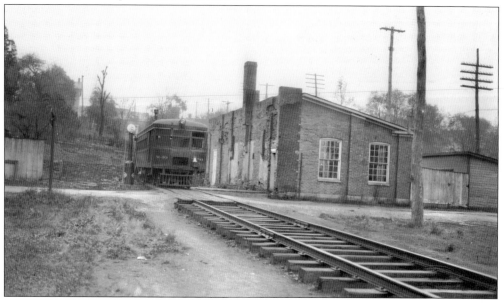

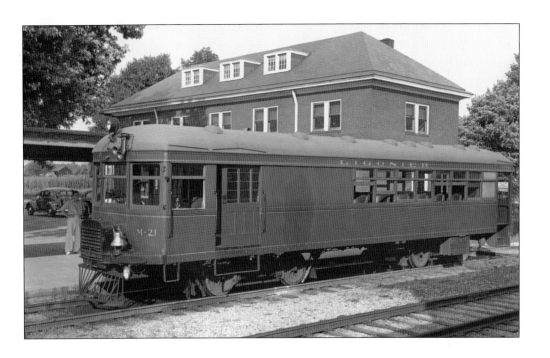

These two views of the M-21 doodlebug were taken 10 years apart at the Ligonier station, in 1939 (above) and in 1949 (below). The M-21 was the workhorse for the LGV, transporting passengers back and forth between Ligonier and Latrobe on a daily schedule, even on days when railfan specials were run. The usual crew on these regular doodlebug runs included conductor Denny Piper and engineer Fred Iscrupe.

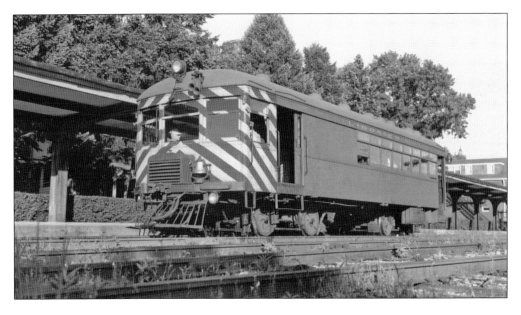

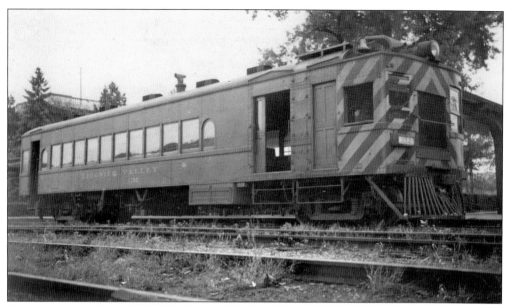

One of two gas-electric doodlebugs, No. 1152, seen in these two photographs, used a gasoline engine to power a generator that provided electricity to traction motors, which, in turn, applied force to the axles and wheels. Modern-day diesel locomotives apply this same concept, but with a diesel engine. No. 1152 is seen above after completing its run from Latrobe. Below, No. 1152 tows the M-10 as a trailer and awaits the scheduled departure time for Latrobe. Also seen in the photograph below is a reminder of World War II. Ligonier had its own civil defense plane spotters during the war. Their mission was to spot and identify all aircraft in the area. In this 1946 photograph, the civil defense shelter is still standing on top of the station.

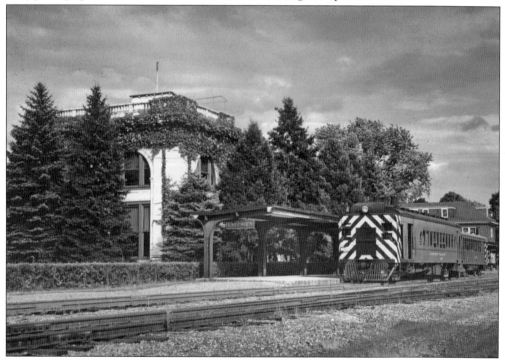

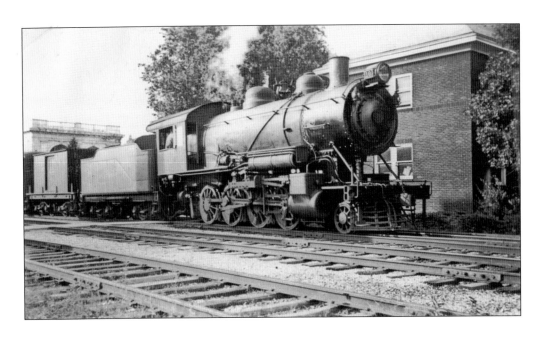

No. 18, a 2-8-0 Consolidation, was purchased new from Baldwin Locomotive Works in 1915 for $15,600. It was the fourth of the five new Consolidation 2-8-0 locomotives purchased by the LGV between 1912 and 1916. Although No. 18 was designed for freight service, as seen in these photographs, the LGV occasionally pressed her into passenger service. In 1949, No. 18 was cut up for scrap in the Ligonier yard. The homemade baggage car No. 27 is visible in both views.

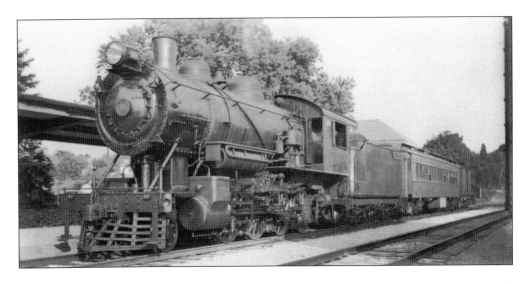

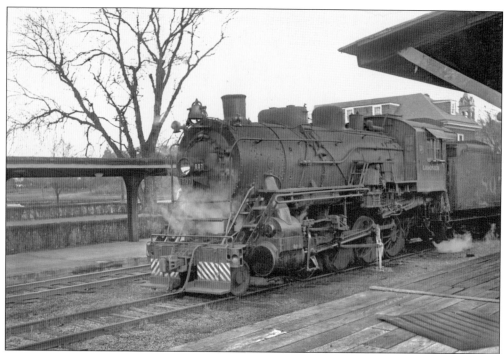

No. 807, built by Baldwin for the Southern Railway in 1910, is seen in this winter photograph at the Ligonier freight station. It must have been standing for a while when this photograph was taken, as ice had already formed below the air compressor. Normally used for the routine freight service, No. 807 was given the honor of leading the Last Run.

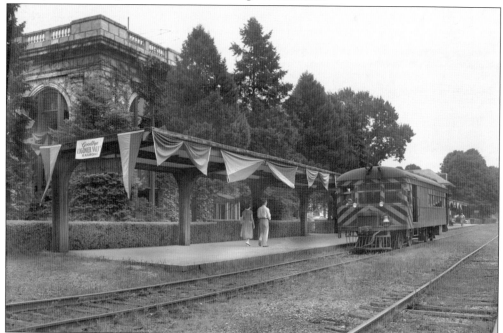

With the Last Run bunting in place, the M-21 doodlebug awaits passengers for its last regular service run, probably on August 30, 1952, the day before the Last Run was scheduled.

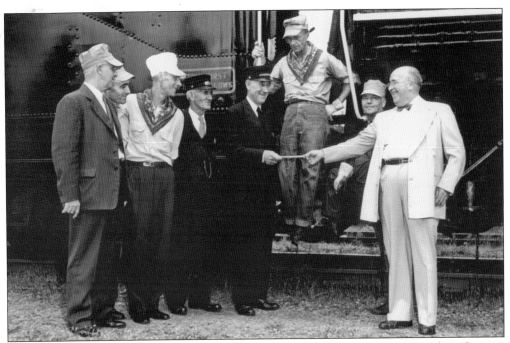

August 31, 1952, marked the end of an era in Ligonier history. Here, dispatcher Milton Geeting issues the Last Run train orders to conductor Denny Piper. The longtime employees in this photograph are, from left to right, Art Burns, John Volpe, Reed "Spoony" Knox, John Holman, Piper, Ed Blair, Fred Iscrupe, and Geeting.

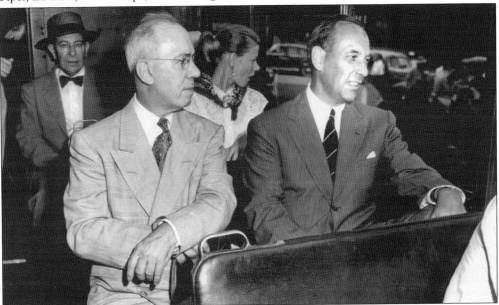

More than 400 people bought tickets to ride the celebrated Last Run of the LGV, sponsored by the Ligonier Chamber of Commerce, on August 31, 1952. At both ends of the line, in Ligonier and in Latrobe, there were ceremonies that included speeches and bands. General manager Joseph P. Gochnour Jr. (left) and A.W. Schmidt, the vice president of the LGV, are seen here sitting together during the Last Run.

Water Tank, Ligonier, Pa.

The pre-1922 water tower seen here was located along the leg of the wye leading to Market Street. Partly visible on the left is the lean-to of the original two-bay engine house. Down the line to the right, but out of sight, stood the LGV summer station, which serviced Frank's Hotel, the feed mills at Market Street, and the Byers-Allen sawmill, east of town.

The Ligonier wye crossed Main Street at grade level in two places, necessitating a flagman. Main Street at this time was still Route 30, and each crossing by the LGV impeded the flow of traffic on the highway. This August 31, 1952, photograph, taken during the Last Run, shows the back end of the M-10 clearing the street and the flagman directing traffic.

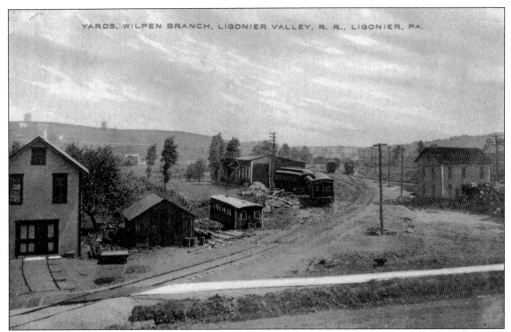

The north end of the Ligonier wye was also the beginning of the Mill Creek Branch, as shown in this early postcard. The two-story toolhouse (left) was retired in 1922, the same year the new engine house was built. Two coaches are parked in front of the car shop, in the center of the image. The building to the right belonged to Prof. Edwin Dickinson.

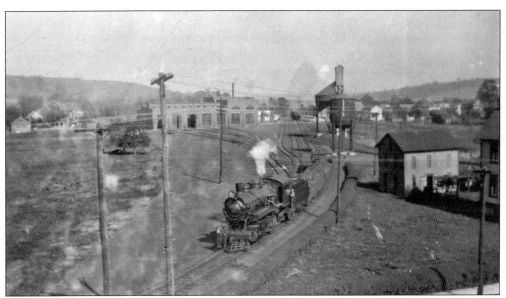

Taken from a similar vantage point as the photograph above but at a later time, this view shows many of the improvements to the railroad's infrastructure made during the tenure of general manager William V. Hyland. The most obvious is the five-bay engine house built in 1922. Additionally, the water tower and the combination coal and sand tower behind it were added during Hyland's 14 years at the helm.

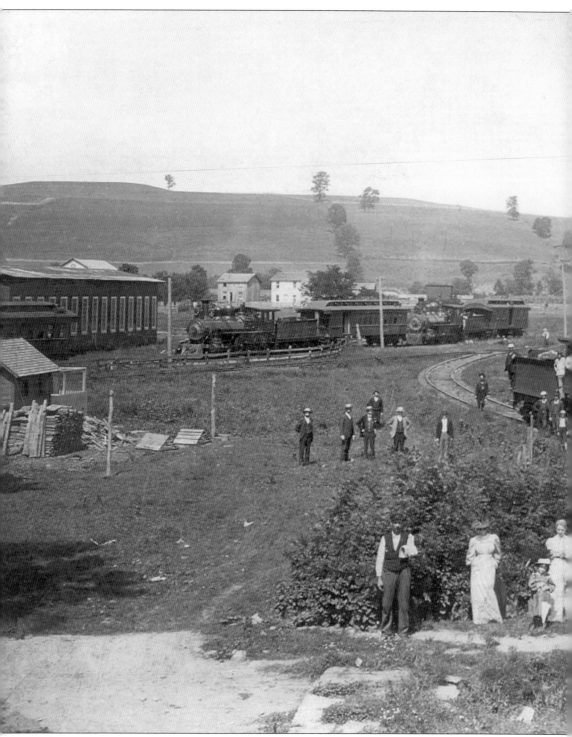

Eight PRR engines are visible in this view, taken from the Ligonier station. Each would have already unloaded passengers at Idlewild before continuing to the wye to turn around and refuel. This photograph substantiates sources that reported crowds as large as 8,000 people traveling to

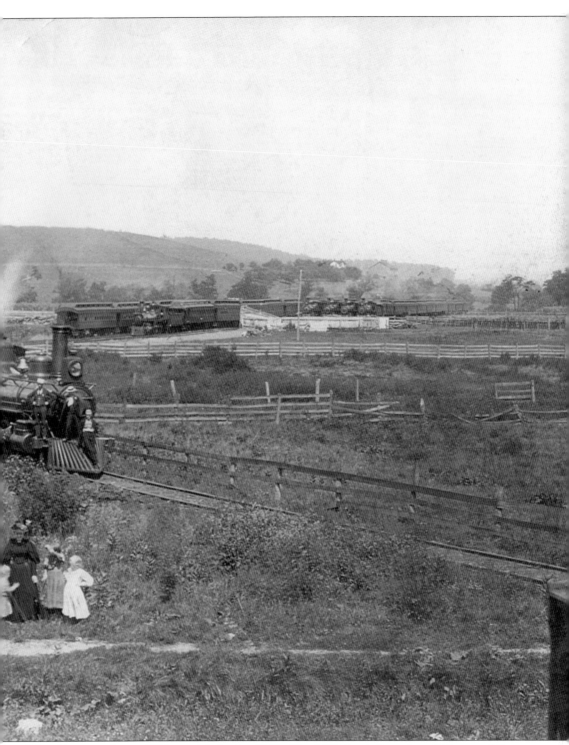

Idlewild in one day on PRR specials in the 1890s. The Mill Creek Branch to Wilpen and Fort Palmer extends beyond the trains visible in the upper right. (Courtesy of the Pennsylvania Room of the Ligonier Valley Library.)

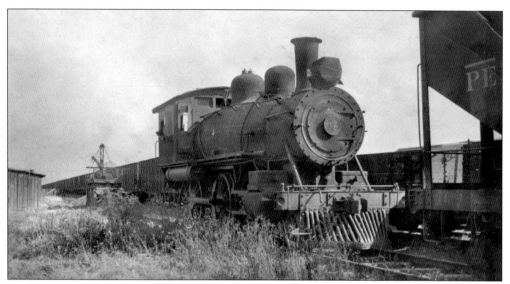

No. 17, purchased new from Baldwin in 1914, had only been on the roster for 20 years when it fell victim to the Depression. The purchase of the M-10 doodlebug in 1928 was intended to end the use of steam power to pull passenger trains. No. 17 was retained as a source of spare parts for the other Baldwin locomotives. The frame of the tender was used as the base for homemade baggage car No. 27.

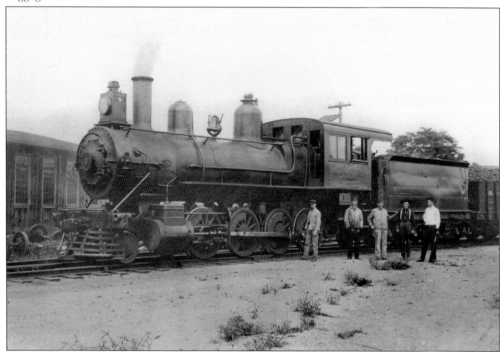

When the coal and coke business expanded, the LGV bought more powerful engines. No. 9, a 2-8-0–class H3, was built by the PRR in Altoona in 1889 and sold to the LGV in 1905. One of four named locomotives on the roster, it was dubbed *Latrobe*. The crew members seen here are, from left to right, Frank McConnaughey, Smith Beatty, John Holman, George Byers, and Denny Piper. McConnaughey, Beatty, and Byers died in the July 5, 1912, accident.

Pittsburgh-Des Moines Steel cited LGV's water tank as a "special problem" in its Railway Service Tank brochure. The company needed "to supply locomotives on two curved tracks and in so doing locate the water tank where it would not interfere with other work." Once alterations to the standard tank solved the problem, it was erected between the two legs of the wye leading to the Mill Creek Branch.

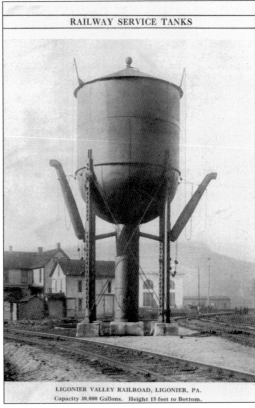

RAILWAY SERVICE TANKS

LIGONIER VALLEY RAILROAD, LIGONIER, PA.
Capacity 30,000 Gallons. Height 15 feet to Bottom.

The photograph below reveals that the base of the water tank was later enclosed. The six-man work gang seen here on the left is heading toward Wilpen, riding a speeder pulling a trailer.

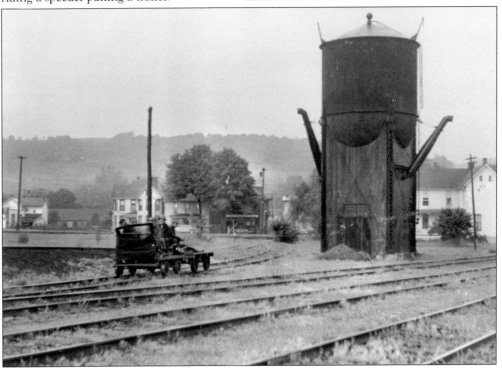

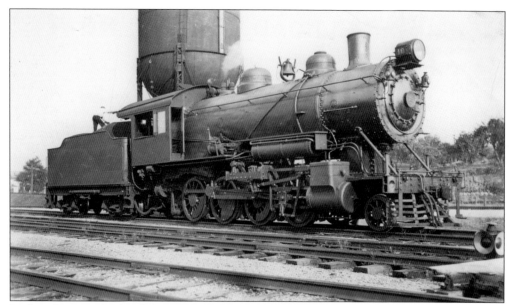

In this photograph, dated August 24, 1936, No. 18 is taking on water at the Ligonier yard in preparation for another day's operation. Bought new from Baldwin in 1915, it remained in service until 1949, when it was replaced and cut up for scrap.

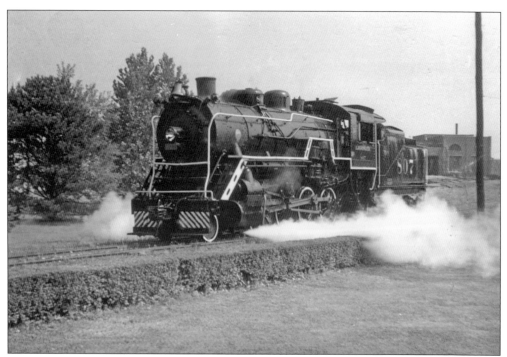

No. 807, a Consolidation (2-8-0), was built by Baldwin in 1910 for the Southern Railway, which sold it to Ligonier in 1948. It is seen here with a fresh coat of paint ready to lead the commemorative Last Run of the LGV.

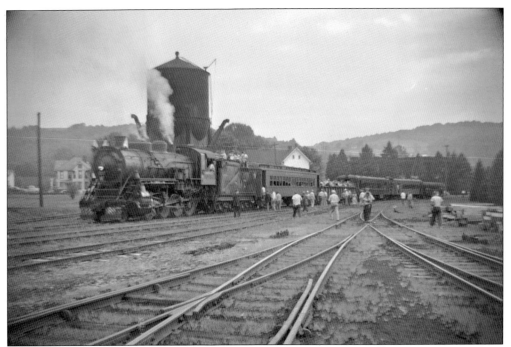

This railfan special, organized by Bill Smith and the members of the Penn-Ligonier Railroad Club, consisted of coach No. 25, an open gondola for the nature lovers, and three doodlebugs—Nos. 1150, 1152, and M-10—used as trailing coaches. On this day, August 12, 1951, No. 807 led the special.

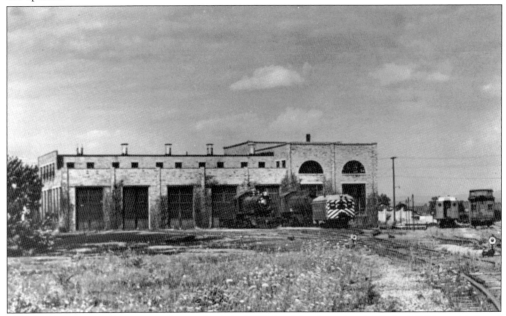

This 10,000-square-foot engine house, built in 1922, had five bays in which the LGV serviced and stored its equipment. To the right of the bays is a 2,600-square-foot machine shop. A forge shop with a second-floor storage area is behind the machine shop, out of sight. In this 1946 photograph, two engines, a doodlebug, a coach, and a caboose are staged in the Ligonier yard.

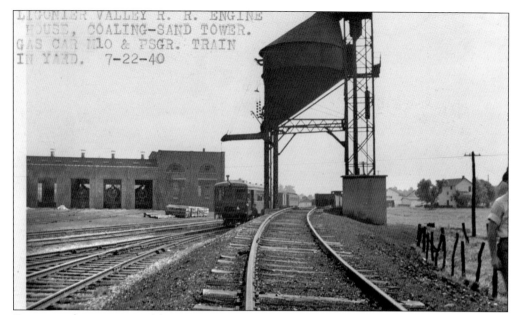

To capture this 1940 view of the engine house, the photographer gained some elevation by standing on the elevated grade of the supply track to the LGV coaling station. Steam engines occupy three bays of the engine house, and the M-10 stands by the coaling station.

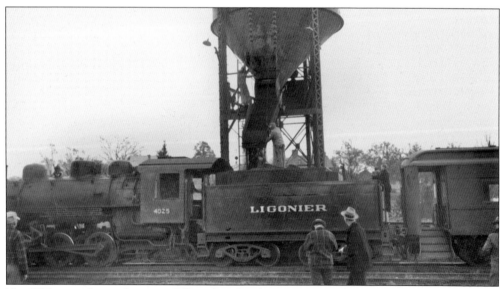

No. 4025 is seen here taking on a full tender of coal in preparation for an October 24, 1948, railfan trip. Even though it was designed for switcher service in a railroad yard, No. 4025 could be called upon for any type of service, as was true for all of the engines on the LGV roster.

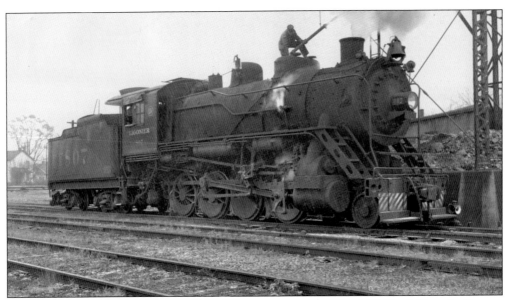

An employee fills the sand dome of No. 807 prior to a run on the Mill Creek Branch. On wet and dreary days like this one, sand was needed for more efficient wheel-to-rail adhesion. The grade on the main line of the LGV was relatively mild, but between Wilpen and Fort Palmer, the gradient exceeded 1 percent, and it reached 2.1 percent as the line neared Fort Palmer, thus requiring traction sand.

In this 1940 photograph of the sand and coal tower, the stub-end track extends underneath it where coal and sand were dumped out of hopper cars. Employees used a power-driven chain-bucket system to elevate coal to the lower bin and sand to the higher one. The water tower stands directly behind the sand and coal tower; beyond it, on the immediate right, is the Main Street side of the ivy-covered station.

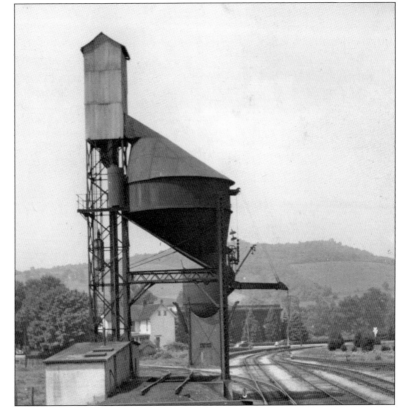

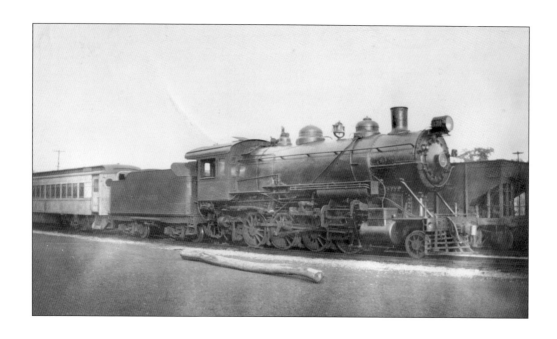

The opening of the Mill Creek Branch into the coalfields north of Ligonier required more powerful engines to handle the volume of freight traffic. In response, between 1909 and 1915, the LGV purchased five new 2-8-0 Consolidations—Nos. 12, 15, 16, 18, and 19—from Baldwin to handle the increased demands on the line. On April 30, 1909, No. 12, pictured above, was the first to be delivered. In the 1948 photograph below, made four years before the end of the line, No. 12 was already retired and stripped of its headlight and bell; soon after, it was cut up for scrap metal. Today, No. 12's headlight is on display at the Ligonier Valley Rail Road Museum in the restored Darlington station.

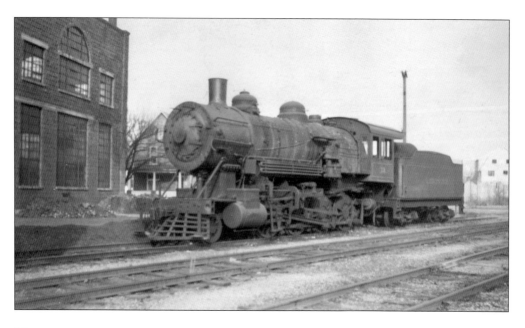

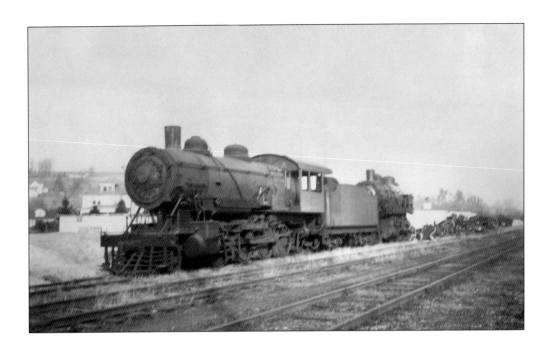

The photographs on this page show three LGV Baldwin engines in the process of being cut up for scrap in the Ligonier yard. The scrappers, working their way from back to front, have already reduced No. 18 to pieces. No. 15 is about halfway dismantled, while No. 19, in the foreground, will be the last to go. These Baldwin locomotives were taken out of service in 1948 but were not cut up until 1949.

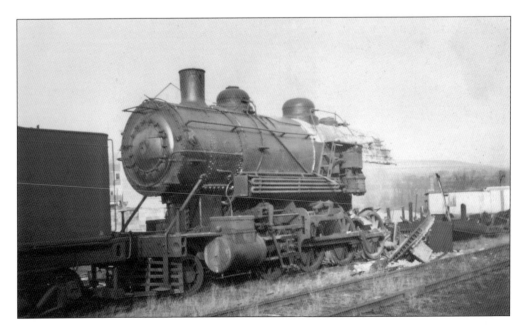

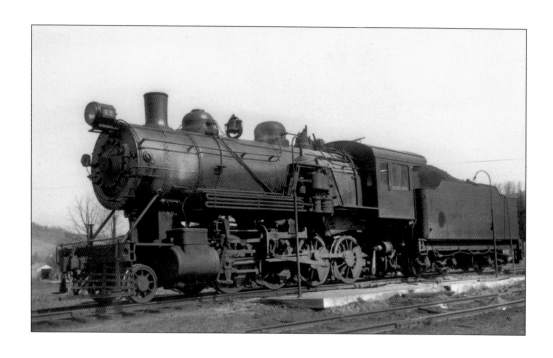

No. 15, the second new Consolidation purchased from Baldwin, arrived in September 1912. In the photograph above, it is positioned at the ash pit, where routine servicing of a steam engine included the dumping of accumulated ashes and the cleaning of the ash pan. No. 15 is seen below in passenger service, with baggage car No. 27 and coach No. 25 trailing.

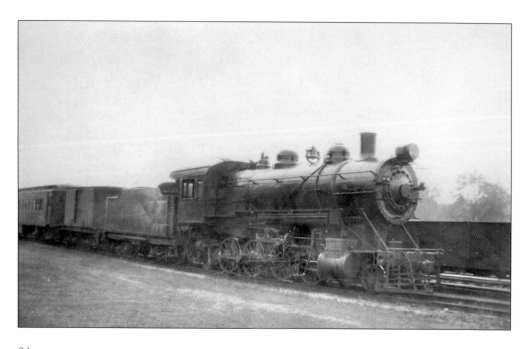

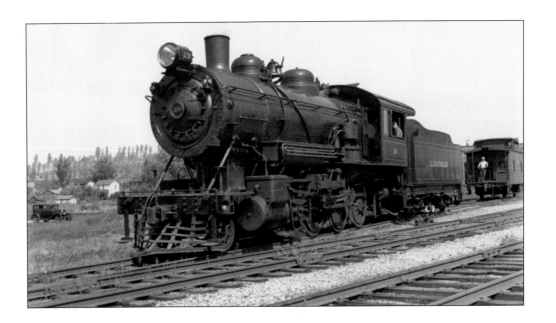

No. 19, the last new engine bought by the railroad, arrived in Ligonier in May 1916. In the above photograph, dating from the late 1930s, the engine appears to be well maintained, with its engine number and "Ligonier" road name clearly visible. Fortunately, Bill Smith of the Penn-Ligonier Railroad Club secured the bell, headlight, number plate, and builder's plate before the engine was scrapped in 1949. Jack Emory of Greensburg purchased these four artifacts from Smith for $1,000 in the 1970s and displayed them in his home until selling them to the LVRRA in 2004 for that same price. The LVRRA mounted the 220-pound solid brass bell on a cart and displays it at festivals, including Fort Ligonier Days and Summer in Ligonier, where children of all ages enjoy ringing it.

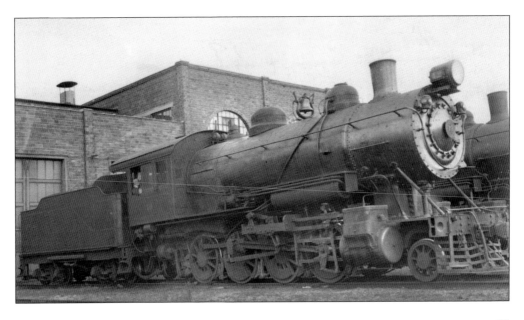

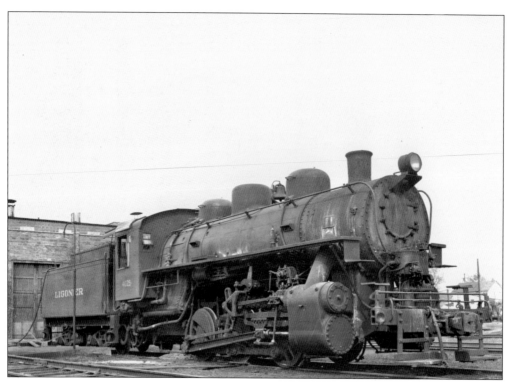

Ligonier acquired three secondhand engines in 1948 and 1949 to replace its four worn-out Baldwin Consolidations, dating from between 1909 and 1916. With a build date of 1942, No. 4025, known as *Little Joe*, was the newest engine ever used by the LGV. Compared to the Baldwin Consolidations, which were aesthetically pleasing to the eye, No. 4025 looked more utilitarian. When the LGV was abandoned in 1952, Luria Brothers purchased the salvage rights to the equipment. Luria then sold No. 4025 to Wheeling Steel, where it remained in service for an unknown length of time, becoming the last piece of Ligonier rolling stock to see service.

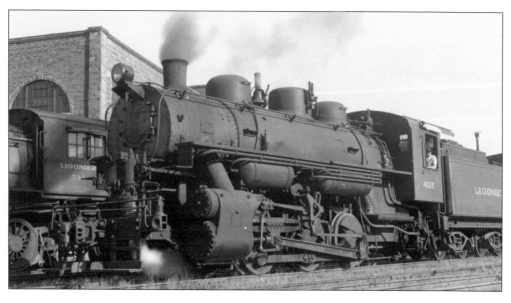

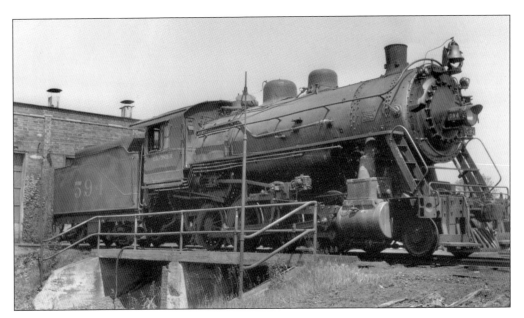

Arriving in February 1950, No. 594 was the last of the three replacement engines acquired by the LGV. It was built by ALCO-Richmond in June 1906 for the Southern Railway and was, therefore, older than the LGV engines it replaced. In the above photograph, No. 594 is positioned over the ash pit at the Ligonier engine house. Below, No. 594 leads one of the Penn-Ligonier Railroad Club specials. The white flags on either side of the engine, indicating an "extra," and the club's keystone emblem, below the number plate, were displayed in honor of the occasion. Trailing are coach No. 25, the two gas-electric doodlebugs, and M-10.

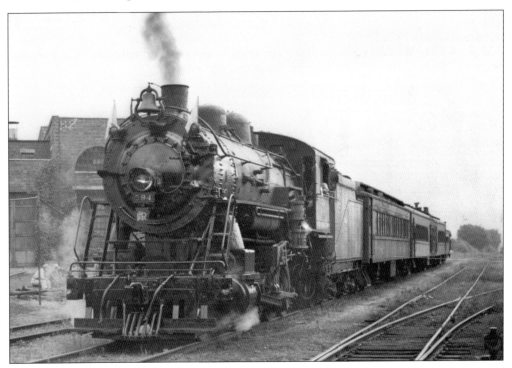

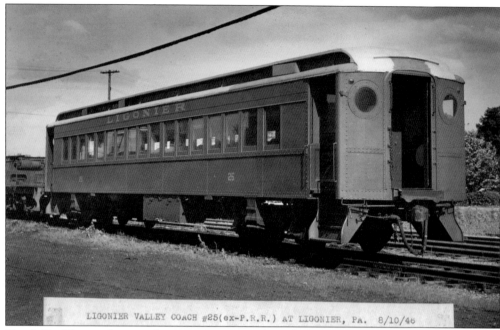

Coach No. 25, one of two steel cars purchased new from the Standard Steel Car Company in 1923, was a full coach capable of seating 72 passengers. The second steel car, No. 26 (not in view), was a combination car and could accommodate 52 passengers and baggage. In 1926, both cars were refurbished and painted dark green. Sometime later, they were painted the more traditional red. Since these two cars were the only passenger cars on the roster in 1926, the LGV had to borrow PRR cars to fulfill the passenger schedule. By 1931, No. 26 was deemed to be surplus—a victim of the Depression—and was retired.

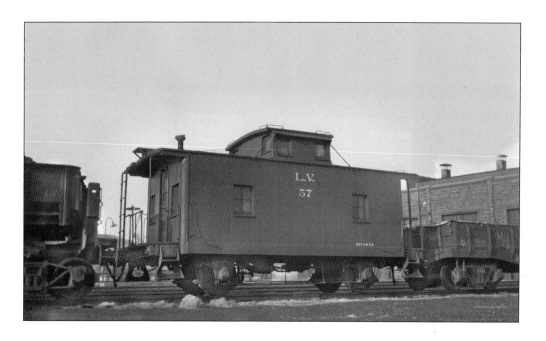

The LGV purchased a former PRR class-ND cabin car in 1936, which served as the conductor's office and as a mobile toolshed. It is unknown why, after operating without a caboose during the LGV's period of heaviest freight traffic, LGV purchased this one in 1936. Built for the PRR in March 1907, the car was already a relic when it arrived in Ligonier. According to the February 10, 1936, issue of the *Pittsburgh Sun-Telegraph*, "After 50 years of the stern life, trainmen of the Mellon-owned Ligonier Valley Railroad are riding in luxury in a new [for LGV] caboose." In the later photograph below, the caboose displays the updated reporting mark, LGV.

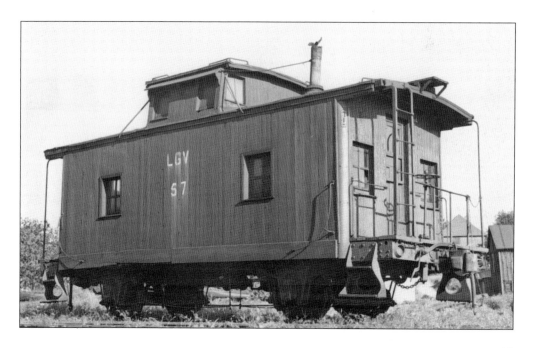

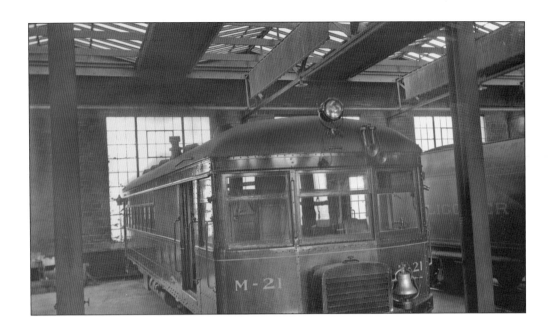

The M-21, a Model 55, was built in 1929 by the J.G. Brill Company for the St. Louis Southwestern Railway. The LGV acquired this second doodlebug in 1937 when the M-10 could no longer accommodate the increased passenger traffic. In the above photograph, before the safety stripes were applied, the M-21 sits in a bay of the engine house, which provided a sheltered and well-lit area where mechanics could service LGV equipment. The overhead heaters were a bonus during the winter months. Characteristic of the LGV, the engine house displays a neat and tidy appearance. In the photograph below, the M-21, sporting the distinctive safety stripes, awaits her call to service.

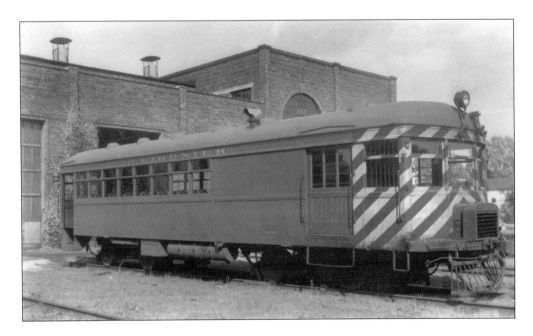

In this 1952 photograph, LGV employees and Bill Smith of the Penn-Ligonier Railroad Club stand on the steps of No. 807, which is parked inside the engine house. From left to right are Smith, foreman Paul Clark, hostler and watchman Frank Becar, truck driver Tony Vucina, laborer Homer McMaster, and clerk Chuck Robb.

Homer McMaster (left) and John Volpe are seen here in the machine shop. McMaster was a teenager when he joined the company in 1952. Volpe was drafted to serve in World War II while he was working at LGV. In the Army, Volpe learned to climb telephone poles, and, upon his return to the LGV, he became the designated pole climber for the railroad. In 2006, he donated his pole-climbing spikes to the LVRRA.

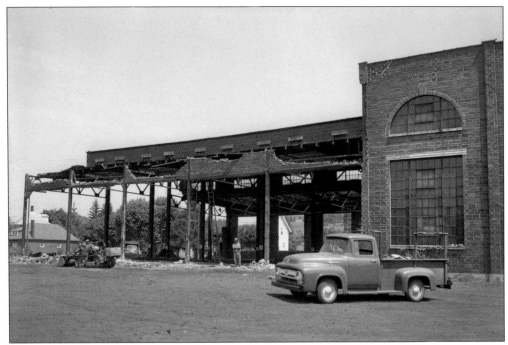

In 1955, Holy Trinity Parish bought the engine house complex and the surrounding six acres of property with the intent of converting the existing building into a church and a school large enough to accommodate Holy Trinity's increasing needs. After removing the front wall and an adjacent side wall of the engine house, Holy Trinity was able to retain the original iron framework to reuse as the superstructure for a two-story school annex and gymnasium. The walls of the taller section on the right were kept intact and brick-faced to match the rest of the complex. The interior was then converted into a modern church.

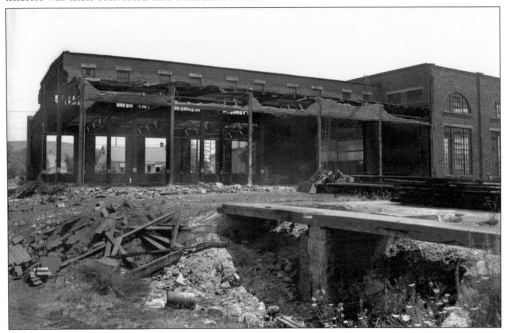

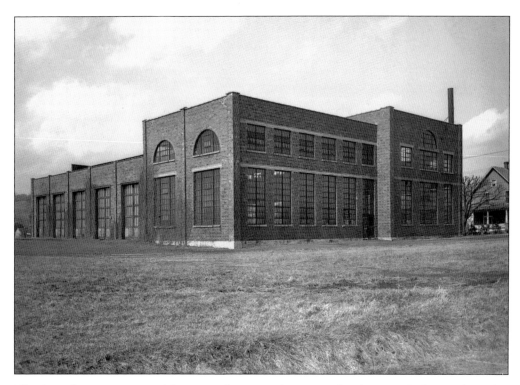

The three distinct sections of the engine house can be seen in the photograph above, taken after the tracks had been removed. The engine house, on the left, had five large doors, each leading into a separate bay. The machine shop was located in the section in the foreground, while the forge shop was on the first floor of the tallest section, on the right. The second floor of that section was used for storage by the railroad and is still used for storage by the church today. As seen in the photograph below, this transformation from a railroad complex to a parish facility was quite dramatic.

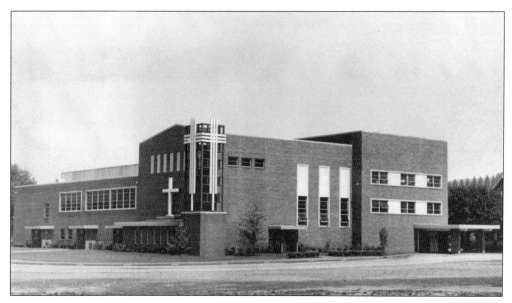

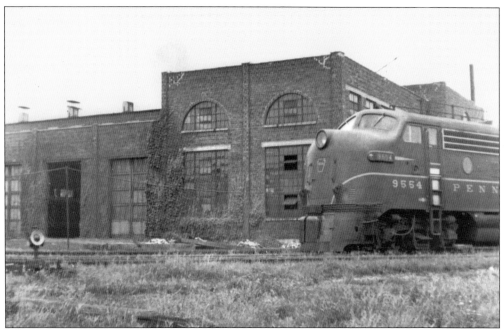

Only one diesel locomotive was ever seen in Ligonier, when this PRR F-3 dropped its coaches at Idlewild and came to Ligonier to turn around. Employee Al Trautmann was the LGV pilot on that train. The year 1952 was one of transition for railroading in the United States, as diesels were fast replacing steam locomotives. Before its demise that year, the LGV even considered purchasing a diesel.

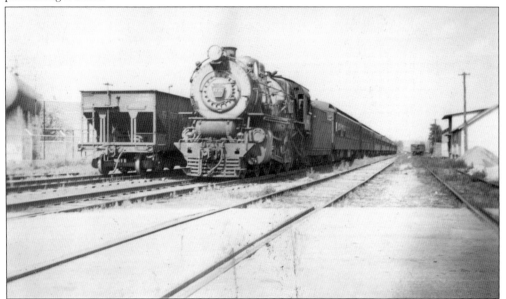

By the time this photograph was taken, around 1948, the number of PRR special trains transporting picnickers to Idlewild had dwindled considerably. At times, there was only a single train. This PRR special is seen here parked at the beginning of the Mill Creek Branch, which extended north of Ligonier through Wilpen to Fort Palmer. The engine is waiting until her scheduled time to pick up passengers at Idlewild Park for the return trip to Pittsburgh.

Five

KING COAL

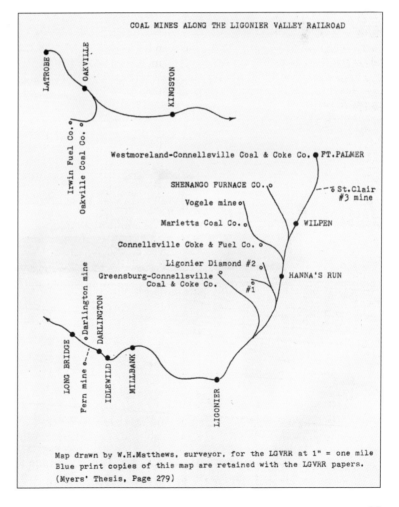

COAL MINES ALONG THE LIGONIER VALLEY RAILROAD

LATROBE
OAKVILLE
KINGSTON

Irwin Fuel Co.
Oakville Coal Co.

Westmoreland-Connellsville Coal & Coke Co. FT.PALMER

SHENANGO FURNACE CO.

St.Clair #3 mine

Vogele mine

Marietta Coal Co.

WILPEN

Connellsville Coke & Fuel Co.

Ligonier Diamond #2
Greensburg-Connellsville
Coal & Coke Co.
#1

HANNA'S RUN

Darlington mine
DARLINGTON

LONG BRIDGE
Fern mine
IDLEWILD
MILLBANK

LIGONIER

Map drawn by W.H.Matthews, surveyor, for the LGVRR at 1" = one mile
Blue print copies of this map are retained with the LGVRR papers.
(Myers' Thesis, Page 279)

For decades, people were aware that outcroppings of the famous Pittsburgh Seam of coal were located north of Ligonier. Once the LGV constructed its Mill Creek Branch in 1904 to reach the outcroppings, mines sprang up along the line. By December, the Colonial Coal & Coke Company, labeled "Greensburg-Connellsville" here, became LGV's first customer on the branch line. By the end of the next two years, coal shipments had increased from 10,689 tons to 199,919 tons.

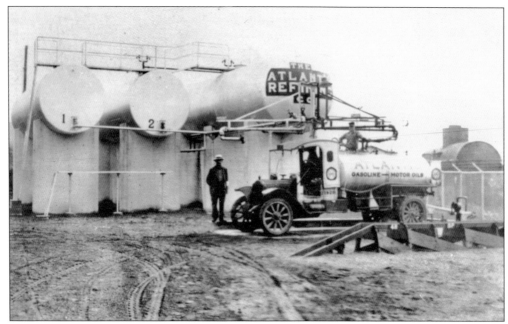

Even though coal was "king" along the Mill Creek Branch, other businesses located their facilities along the branch, including this distribution center for Atlantic Refining. Incoming petroleum products arrived in tank cars via the LGV, were transferred to storage tanks, and were then distributed locally by truck. Two of the concrete pillars that supported the elevated tanks remain in use today as opposing walls of a toolshed.

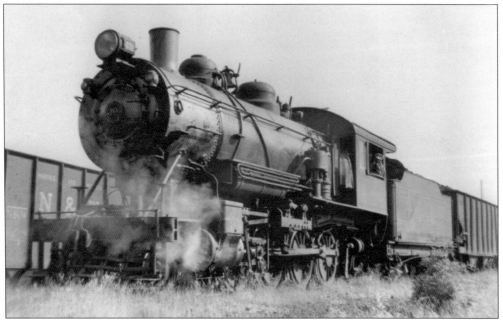

In 1947, when this photograph of No. 19 hauling coal cars was taken, the mines were almost depleted, and, after 30 years of service, No. 19 was almost worn out. Coal shipments over the LGV rapidly fell to levels not seen since the branch was constructed. Between 1904 and 1952, a total of 18.7 million tons of coal and 5.2 million tons of coke were transported over the Ligonier line.

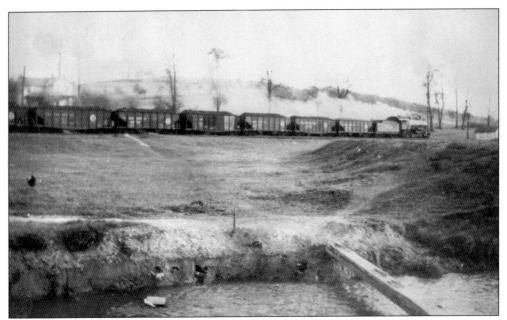

A Baldwin Consolidation heads to Latrobe with a trainload of coal. At Latrobe, the cars were weighed and set out on an interchange track until they were picked up by the PRR.

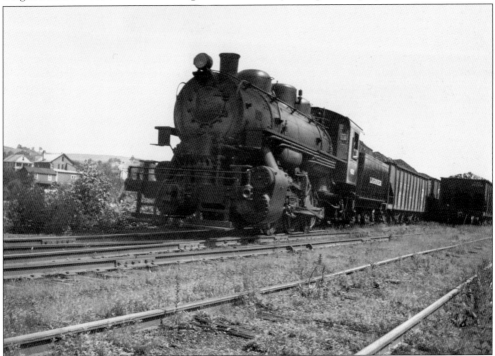

No. 4025, *Little Joe*, sits on the Mill Creek Branch, ready to pull a train of loaded hopper cars to the PRR interchange in Latrobe. By the 1940s, once most of the underground mines were closed, strip miners began to remove coal from the remaining pillars, which was then hauled by truck to loading ramps and dumped into hopper cars. As the need for coal grew during World War II, strip-mining increased to meet the demand.

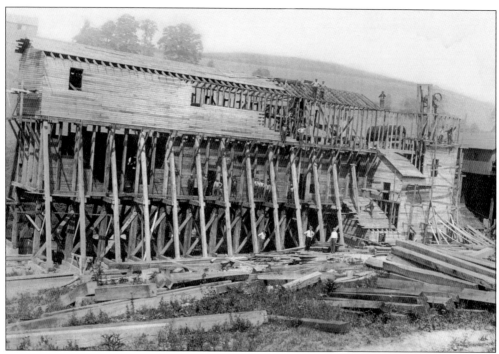

These undated photographs of the Old Colony mine show its tipple under construction (above) and completed (below). This company built the first coal and coke plant on LGV's Mill Creek Branch. To the left, out of view, Colonial built its first bank of 50 beehive coke ovens late in 1904, and made its first shipment early in 1905. That year, an additional 50 ovens were built, and 28 more were built later. The mine, which changed names and owners two more times, was worked out and abandoned in 1925. (Both, courtesy of the Pennsylvania Room of the Ligonier Valley Library.)

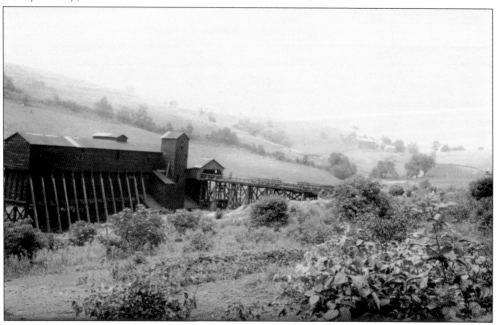

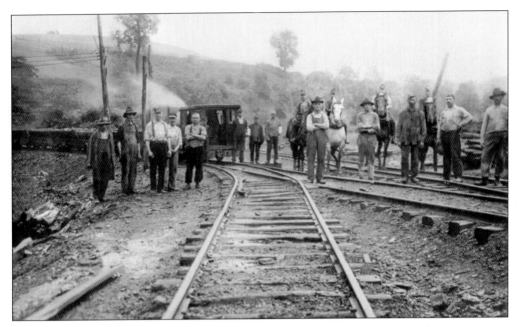

As seen above, miners needed both horses and steam-powered equipment to mine the coal at the Old Colony operation. The photograph below shows an overall view of Old Colony's mining operation. The beehive ovens are just out of view to the right. Construction on a second entry into the coal seam, approximately half a mile away, resulted in the opening of Old Colony No. 2 in 1907, which began operating the following year. George S. Baton's Greensburg-Connellsville Coal & Coke Company bought both mines and the coking operation in 1912. The company added 28 additional ovens and a coal washer the next year. (Both, courtesy of the Pennsylvania Room of the Ligonier Valley Library.)

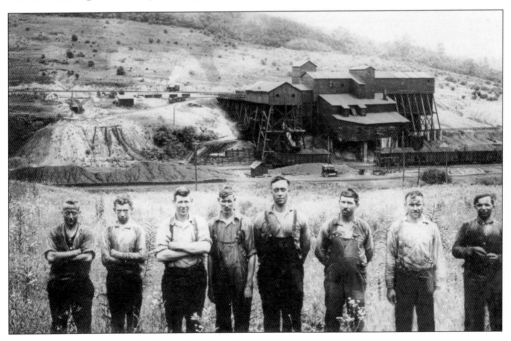

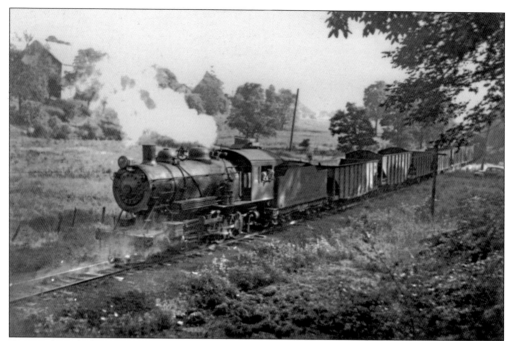

An unidentified Baldwin Consolidation, either No. 18 or No. 19, backs its train of empties to one of the plants at the north end of the branch. The train is passing the Menzie grade crossing, approximately one mile south of Wilpen.

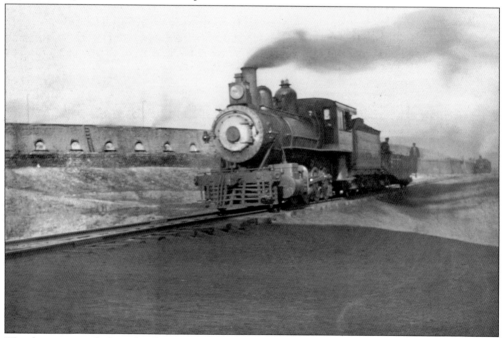

This locomotive, believed to be No. 14, a former PRR H3, was only on the LGV roster between February and July 1912. In the background are the coke ovens of one of the five coking plants located along LGV's Mill Creek Branch. Those five companies together operated a total of 486 ovens in 1912. (Courtesy of the Ligonier Valley Historical Society.)

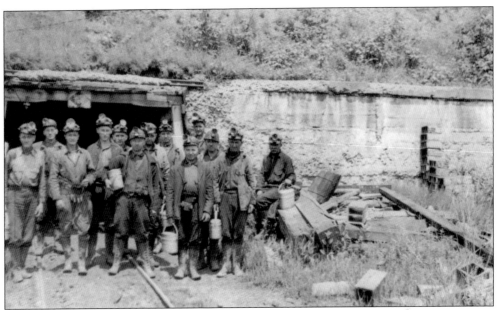

This 1940 view shows the mine entry at Baton Coal Company's Wilpen mine. The Pittsburgh Seam of coal averaged eight feet thick in the hills north of Ligonier. Portals to the mines were direct entries into the hillside and did not require a shaft to reach the coal. Most of the mines on the Mill Creek branch were drift mines, which followed the near-horizontal or upslope seam of coal beneath the ground.

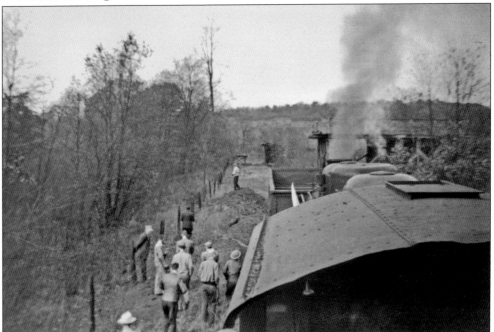

As the underground mines were worked out and abandoned, strip-mining operations moved in if the depth of the remaining coal in the pillars made the venture economically sound. Here, a hopper car is positioned at a temporary loading ramp near one of the strip mines. Trucks delivered the coal from the mine to the railroad and dumped it into waiting hoppers.

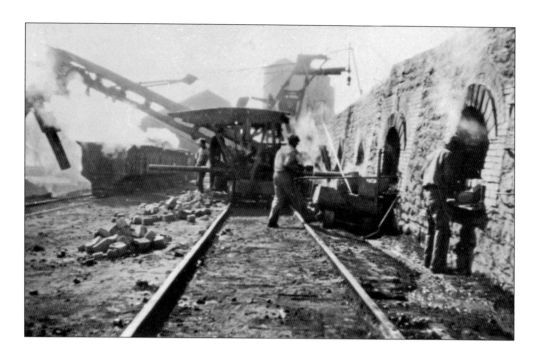

These photographs were taken at the Wilpen coke works of the Baton Coal & Coke Company in the 1940s. The worker seen on the far right above is bricking up the face of the oven to fire the next load. The next worker, to the left, is leveling a charge of coal to achieve a uniform "burn." In the photograph below, the machine behind the workers is loading coke into a car for transport to the next operation.

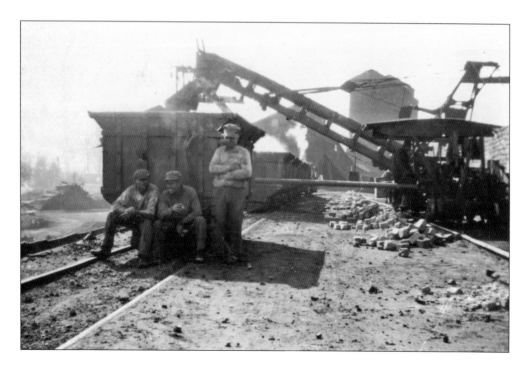

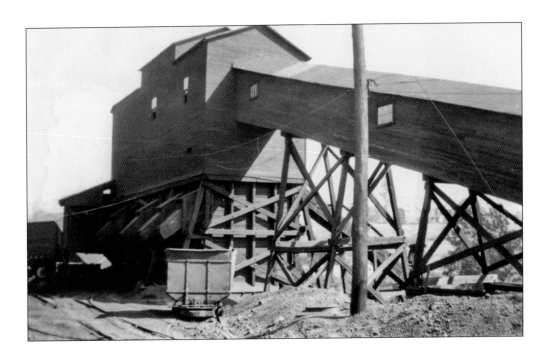

Steel mills preferred large chunks of coke to fire their gigantic furnaces, while foundries required crushed coke because of their smaller furnaces. The photograph above shows the coke crusher owned by the Baton Coal & Coke Company in Wilpen, which supplied coke to foundries. Raw coke was conveyed to the top of the structure, where it was then crushed into smaller pieces and loaded into hopper cars, as seen below.

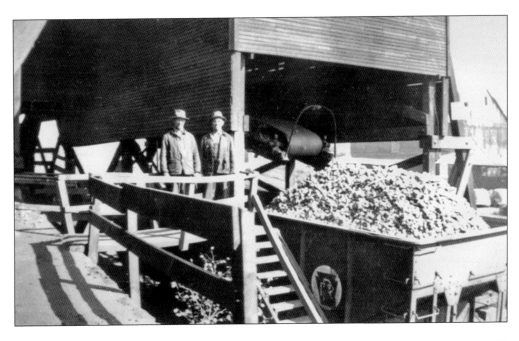

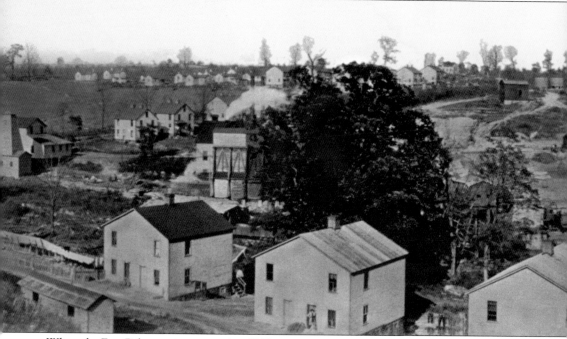

When the Fort Palmer mine opened in 1908, a company town sprang up to house the workers, as seen in this split panoramic view. The Fort Palmer works also included a coking operation that was unique in the entire Upper Connellsville region. It is described in a May 1914 issue of the *Connellsville Weekly Courier*: "There is one plant of Belgian ovens in the Upper Connellsville region, the Fort Palmer works of the Westmoreland-Connellsville Coke Company. The installation

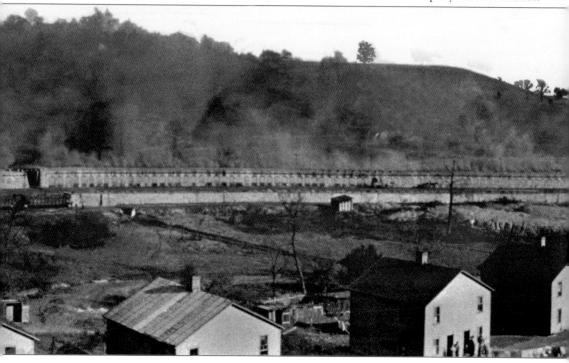

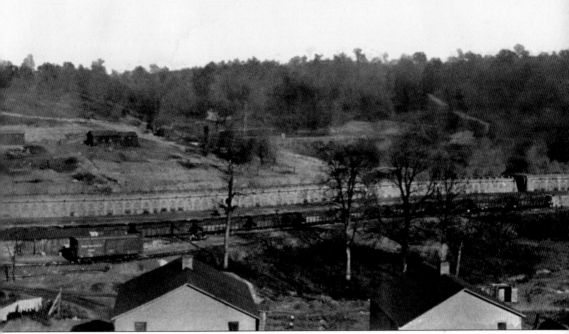

of 161 ovens has been in operation about a year. The Belgian Coke Ovens are equipped with flues which retain much of the heat and improve combustion. Although designed primarily for coking lower grade coals they give great satisfaction with the Upper Connellsville coal. All other ovens in the region are of the bee-hive type."

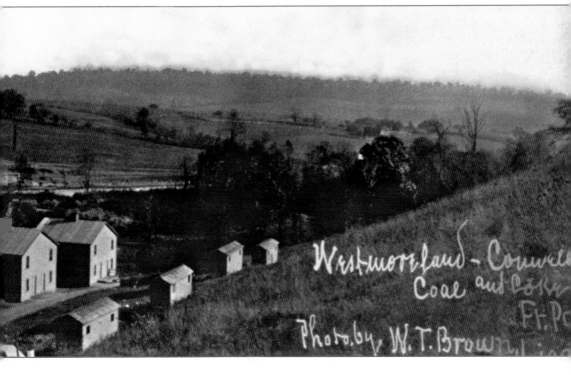

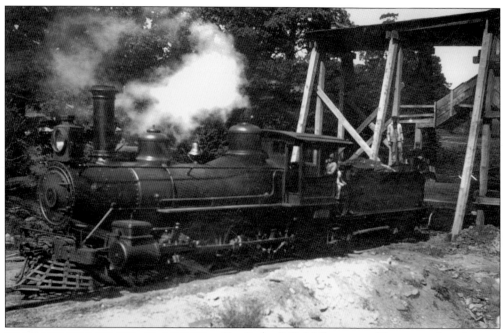

No. 7, the *R.B. Mellon*, one of four named engines on the LGV roster, was purchased new from Baldwin in June 1889. It is seen here taking on coal at the Fort Palmer tipple between 1908, when Fort Palmer opened, and 1912, when the No. 7 was destroyed in the train wreck on the Mill Creek Branch.

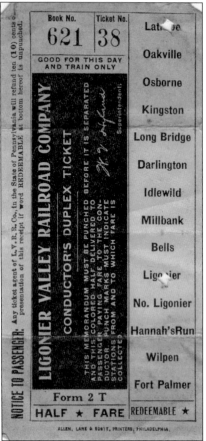

This ticket dates from the administration of William V. Hyland and includes the stations along the Mill Creek Branch. Through 1917, there were two passenger trains scheduled daily on the branch: a morning run and an afternoon run. The morning trip was discontinued on July 1, and the afternoon run followed on December 18, when Hyland ordered all passenger service on the branch to be discontinued "due to interference with the movement of coal and coke."

Six

TRAGEDY STRIKES

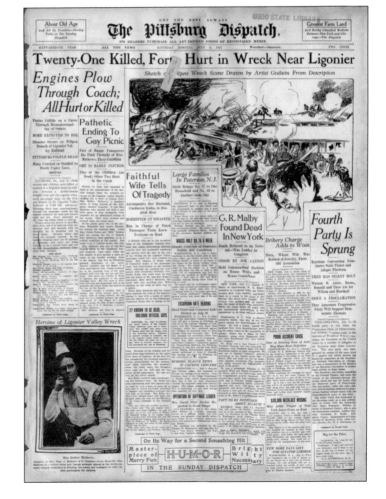

The front page of the *Pittsburg Dispatch* was devoted to the news of the horrific train wreck on LGV's Mill Creek Branch, which killed 24 people and injured many more. In a fateful deviation from normal procedure, the freight conductor was given verbal permission to override the scheduled time of the passenger train. The corresponding verbal order to the passenger conductor, however, was misinterpreted, resulting in the two trains colliding.

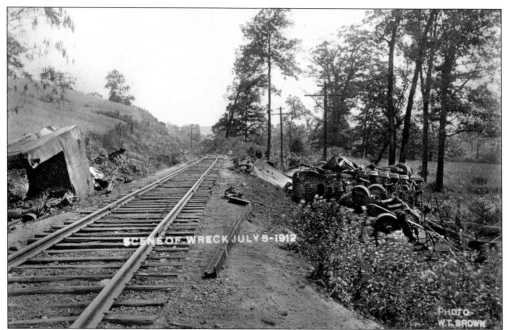

These two photographs of the wreck scene were taken after the track had been returned to service. The view above faces Wilpen, and the view below faces Ligonier. The wreck occurred just south of the blind curve seen above, where visibility was less than 200 feet. A double-headed coal train from Wilpen rounded the curve just as an oncoming passenger train approached it from the opposite direction. The freight train, which was traveling between 20 and 25 miles per hour, consisted of Nos. 7 and 14 pulling 14 loaded hoppers. The passenger train, traveling at about 10 to 15 miles per hour, was made up of No. 10 (2) pushing a single wooden combination coach. It was too late for any action to prevent the accident.

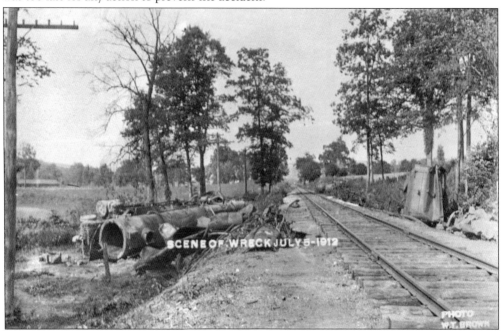

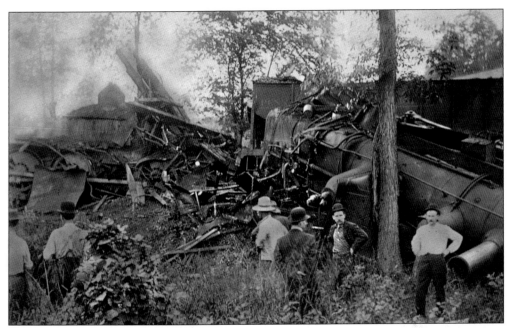

The lead engine on the double-headed freight was No. 7, which is seen here, to the left of center, still covered with the shattered remains of the coach. As a result of the collision, the second engine, No. 14, jackknifed, landing on its right side jammed against a hickory tree. The cabs of both freight locomotives completely disintegrated upon impact, and the tenders were thrown off the track by the momentum of the trailing loaded hoppers.

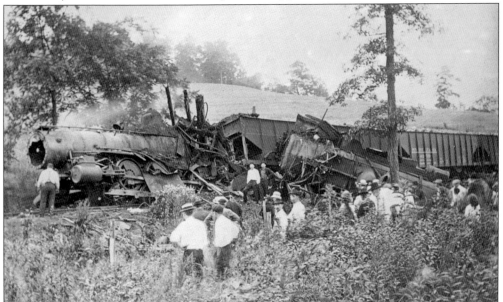

When this photograph was taken, much of the debris had been removed from No. 7, seen on the left. The passenger coach and the cabs and tenders of the freight engines acted as shock absorbers, resulting in only the lead truck of the first hopper car derailing. Although the engineers reversed their engines in a desperate attempt to avoid impact, there was too little time and distance to avert the accident.

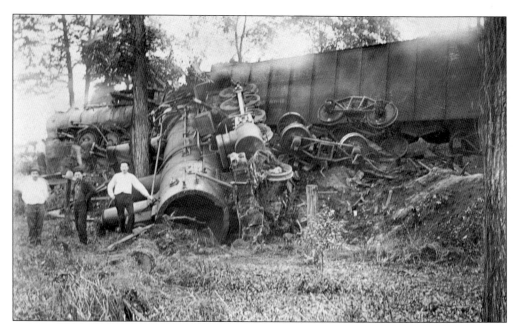

Although these views of the carnage from another perspective make it almost impossible to imagine that anybody could have survived the accident, the number of survivors exceeded the number of those killed. The coach, which was being pushed toward Wilpen by No. 10 (2), was filled to capacity with passengers, many of whom were returning home after the Fourth of July holiday. Also on their way to Wilpen to pick wildflowers were several children accompanied by a nurse, including general manager George Senft's granddaughter. The collision literally split the coach in half, throwing its passengers helter-skelter, with some of them even ending up on the track beneath. What was left of one side of the coach is visible below, lying on the bank to the right.

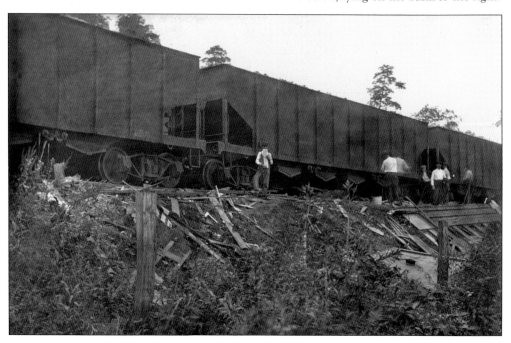

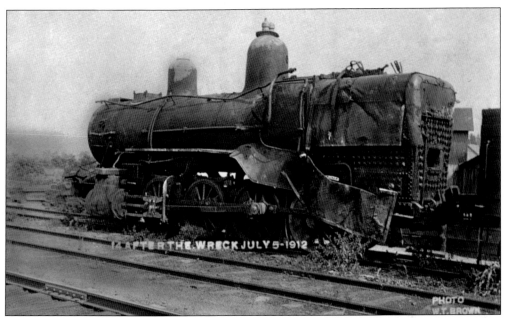

The damage to both engines of the freight train can be seen on this page. Because of the extensive damage, neither of the engines could be salvaged. No. 14 (above) had only been on the LGV roster for five months. Both the engineer, F.F. McConnaughey, and the fireman, George Byers, on No. 14 suffered fatal injuries and died at the scene. No. 7 (below) was the lead engine in the double-headed train. Its engineer, Smith P. Beatty, suffered serious injuries and died several days later. Fireman John Ankney died while en route to the hospital. No. 10 (2), which was pushing the passenger coach, suffered only slight damage and was repaired, remaining in service on the LGV until 1921. No. 10 (2)'s engineer, Tom Dunlap, and its fireman, Walter Byers, were not injured.

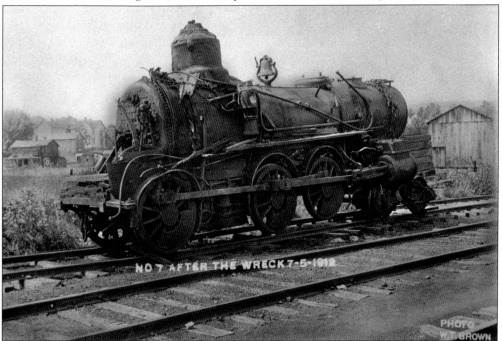

Harry H. Knox, the conductor of the coal train, survived the accident. He began working for the LGV prior to 1899 and was still listed as a conductor in 1916. Although his phone call requesting permission to override the passenger train schedule was the precipitating event that caused the accident, he was deemed blameless for the wreck because he had received permission to proceed to Ligonier.

Besse Hoon, age 16, survived the wreck. Attendants initially believed she had died, and laid her body on the hospital grounds. Later, an attendant felt a pulse when he tried to move her body. Although the surgeons considered amputating her leg when they first examined her, they were able to save it. Hoon went on to live a full life as a teacher, wife, and mother until her death at age 69.

Seven

TOURISM AND MORE INDUSTRY

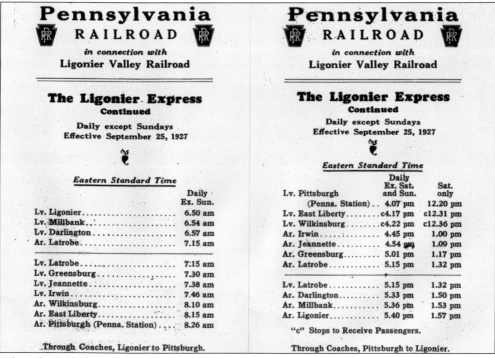

Pennsylvania RAILROAD

in connection with
Ligonier Valley Railroad

The Ligonier Express
Continued

Daily except Sundays
Effective September 25, 1927

Eastern Standard Time

	Daily Ex. Sun.
Lv. Ligonier	6.50 am
Lv. Millbank	6.54 am
Lv. Darlington	6.57 am
Ar. Latrobe	7.15 am
Lv. Latrobe	7:15 am
Lv. Greensburg	7.30 am
Lv. Jeannette	7.38 am
Lv. Irwin	7.46 am
Ar. Wilkinsburg	8.10 am
Ar. East Liberty	8.15 am
Ar. Pittsburgh (Penna. Station)	8.26 am

Through Coaches, Ligonier to Pittsburgh.

Pennsylvania RAILROAD

in connection with
Ligonier Valley Railroad

The Ligonier Express
Continued

Daily except Sundays
Effective September 25, 1927

Eastern Standard Time

	Daily Ex. Sat. and Sun.	Sat. only
Lv. Pittsburgh (Penna. Station)	4.07 pm	12.20 pm
Lv. East Liberty	c4.17 pm	c12.31 pm
Lv. Wilkinsburg	c4.22 pm	c12.36 pm
Ar. Irwin	4.45 pm	1.00 pm
Ar. Jeannette	4.54 pm	1.09 pm
Ar. Greensburg	5.01 pm	1.17 pm
Ar. Latrobe	5.15 pm	1.32 pm
Lv. Latrobe	5.15 pm	1.32 pm
Ar. Darlington	5.33 pm	1.50 pm
Ar. Millbank	5.36 pm	1.53 pm
Ar. Ligonier	5.40 pm	1.57 pm

"c" Stops to Receive Passengers.

Through Coaches, Pittsburgh to Ligonier.

When the LGV began operation in 1877, the trip from Ligonier to the PRR railhead in Latrobe was reduced from four hours to 40 minutes. Commuters and tourists alike took advantage of the new rail service. As seen here, the Ligonier Express eventually reduced the travel time between Ligonier and Pittsburgh to 96 minutes. During its 75-year history, more than nine million passengers rode the rails of the LGV.

Frank's House was built around 1870 by Jacob and Nancy Frank, who promoted it as a "summer hotel." When the LGV began to bring additional tourists to town, business boomed. Other hotels in town expanded, and the Franks responded by building a large resort complex nearby. By 1900, five hotels within two blocks of Ligonier's town square could accommodate as many as 500 overnight guests. This photograph is a current view of what was Frank's House.

LIGONIER, the terminus of the Ligonier Valley Railroad, is one of the historic points of Western Pennsylvania. It is located between the Chestnut Ridge and Laurel Hill at an elevation of 1,200 feet above the ocean. The scenery in this neighborhood is unexcelled while the invigorating mountain air, the crystal spring water and the long, shady drive contribute to make it an ideal health resort. And further Ligonier has excellent railroad facilities and is within less than two hours ride of Pittsburgh. The tourist will here find five first-class hotels and many excellent private boarding houses. There are many fine country homes throughout the Ligonier Valley and in easy reach where the best country boarding may be secured.

ROMANTIC IDLEWILD

Immediately on the line of the Ligonier Valley Railroad, seven miles from Latrobe and three miles from Ligonier, is located romantic Idlewild, beautiful in song and story. This is the ideal picnic ground of Western Pennsylvania and is annually visited by thousands. It is a mountain park magnificent in scenery and unexcelled in its appointments.

LIGONIER VALLEY

RAILROAD

SCHEDULE OF PASSENGER TRAINS

IN EFFECT APRIL 29, 1928

The time given on this table is **Eastern Standard Time.** The time from 12.01 A. M. to 12 o'clock noon, inclusive, is indicated by light-face type; from **12:01 P. M. to 12 o'clock midnight, inclusive, by heavy-face type.**

The time of connecting roads is shown only for the accommodation of the public; this Company will not be responsible for errors or changes that may occur.

JOS. P. GOCHNOUR, JR.
GENERAL MANAGER

The LGV played an important role in developing the tourism industry in Ligonier Valley. Its schedules promoted Ligonier's proximity to Pittsburgh, Ligonier's "five first-class hotels and many excellent private boarding houses" and "Romantic Idlewild," located "immediately on the line" of the railroad.

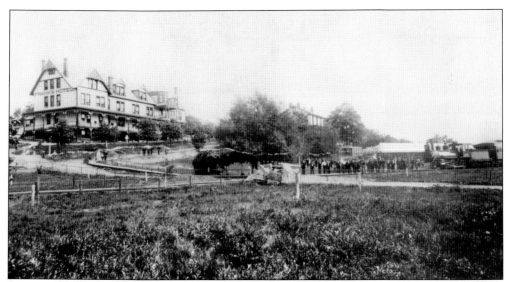

In response to increased demand, the Franks built a large hotel across the street from Frank's House and several nearby cottages. Frank's Hotel and Cottages included amenities such as tennis courts, bowling alleys, a shooting gallery, an ice cream parlor, a telegraph office, elegant grounds, broad porches, and its own summer railroad station for guests. In this photograph, No. 6 is approaching the summer station to pick up passengers. (Courtesy of the Pennsylvania Room of the Ligonier Valley Library.)

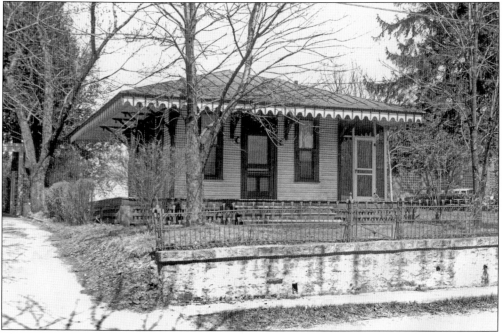

This ticket office for the summer station was built near Frank's Hotel for the convenience of guests. Ticket transactions could be handled here rather than requiring guests to walk two blocks to the Ligonier station. Other features offered by Frank's included first-class dining, accommodations for 150 guests, and its own ballroom and orchestra. (Courtesy of the Pennsylvania Room of the Ligonier Valley Library.)

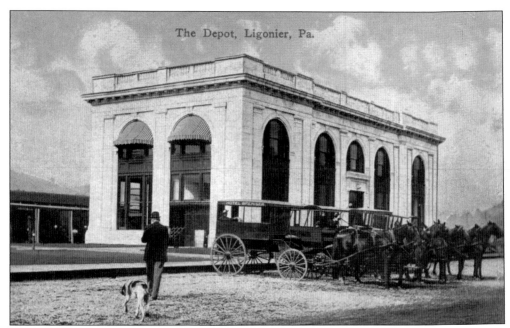

The Depot, Ligonier, Pa.

By 1900, Ligonier had five first-class hotels within two blocks of the town square. Other enterprises, including the Park Hotel and the Kissell Springs Hotel, were located outside of town and attracted their own clientele. Horse-drawn hacks from all these establishments awaited incoming passenger trains at the Ligonier station.

When the LGV came to town in 1877 with its influx of tourists, the need for additional lodging launched a boom in hostelry. One of the many beneficiaries was the Ligonier House, seen here, which was originally a stagecoach stop. It became one of the four hotels near the town square that expanded. A fifth, the Breniser, was built in 1900. (Courtesy of the Pennsylvania Room of the Ligonier Valley Library.)

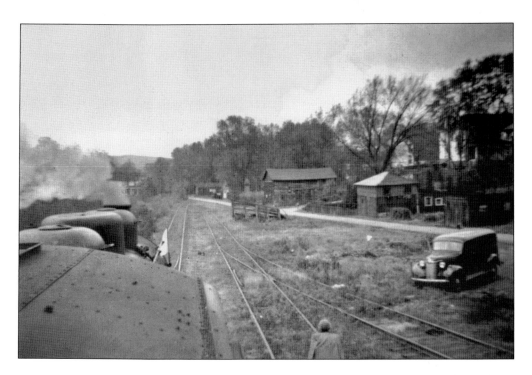

Transporting livestock was another business of the LGV in its early years. The ramp in the center of the photograph above was used to unload the livestock at a distance from the passenger stations, for obvious reasons. In the photograph, the ramp is still standing along LGV's extension between Fairfield and Market Streets. In the photograph below, taken during the same time frame, both of the feed stores on Market Street are visible. As local distributors of grain and fertilizer, these stores needed access to rail service.

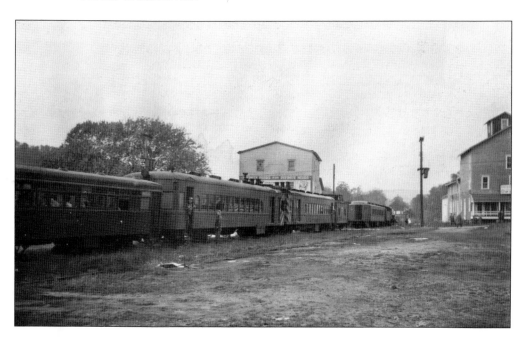

The Byers-Allen sawmill is seen in these two photographs. The photograph above, taken from Market Street, shows the mill in the distance, located east along Loyalhanna Creek. It was built in 1899 to process timber harvested from Laurel Mountain above Rector. The timber was transported to the mill by the Pittsburg, Westmoreland & Somerset Railroad (PW&S), a sister company of the sawmill. Once processed, the lumber was transported to Latrobe by LGV to be picked up by the PRR. The photograph below shows just how large the Byers-Allen mill was. It measured 6,400 square feet and employed between 50 and 80 men, as well as another 100 lumberjacks in the forest. By 1909, the mountain had been clear-cut, resulting in the dismantling and sale of the sawmill.

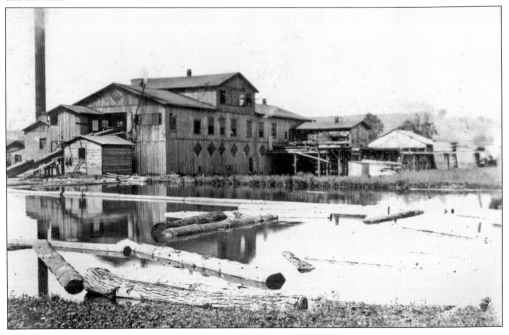

Eight

PRESERVING THE LEGACY

This souvenir edition of the *Ligonier Echo* pays tribute to the LGV, which, after sustaining years of losses, made the decision to shut down. To honor the contributions made by the railroad, the Ligonier Chamber of Commerce orchestrated a commemorative Last Run on August 31, 1952. Hundreds of citizens, railfans, former employees, and current employees enjoyed the bittersweet day.

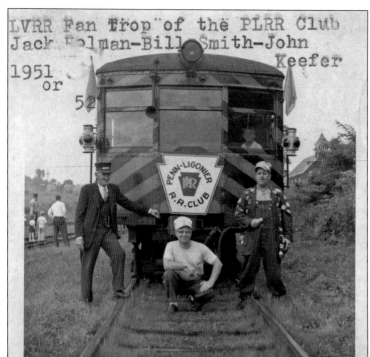

Text in photo: LVRR Fan Trop of the PLRR Club Jack Holman-Bill Smith-John Keefer 1951 or 52

Bill Smith, a PRR employee who lived in Latrobe beside the LGV wye, founded the Penn-Ligonier Railroad Club, which met in his garage. Smith (kneeling in center) housed his extensive railroad collection, much of it LGV-related, in a clubhouse along with a state-of-the-art model train layout. Smith's collection became the foundation of the Ligonier Valley Rail Road Museum.

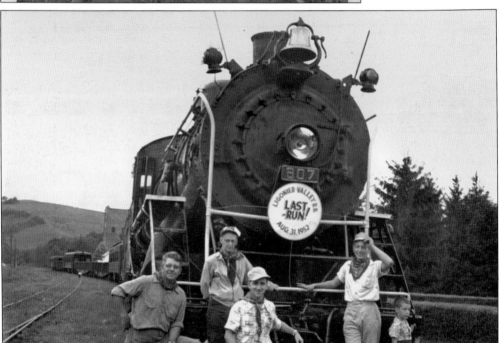

When Smith died and his daughter, Ginger, inherited his estate, she and her husband, Russ Lowden, moved into Smith's house. Russ perpetuated the railroad club, which continued to maintain its layout and Smith's extensive railroad collection. Seen here at the Last Run are, from left to right, Penn-Ligonier Railroad Club members Tucker Fry, Dave Albert, Russ Lowden, and Lester Turner. The boy on the right is Daniel Carnes.

After serving the railroad from 1910 to 1952, the Ligonier station of the LGV was sold in 1955 to the Pennsylvania Game Commission to serve as its Southwest Division Headquarters. The station's spacious lobby became an exhibition hall for the game commission's taxidermic collection. During the game commission's ownership, the station experienced few changes other than the removal of the balusters and the railing from the roof.

In 2001, after outgrowing the station, the game commission swapped properties with the Ligonier Valley School District. Upon gaining ownership, the school district extensively remodeled the station to become its central administration building. Seen here during the 2012 Fort Ligonier Days celebration, the school district's building remains an impressive reminder of the LGV and its Ligonier station.

The former engine house complex of the LGV now functions as part of the Holy Trinity Parish facility. It is hard to believe that this whole area was once a bustling engine house and railroad yard during the LGV's boom days.

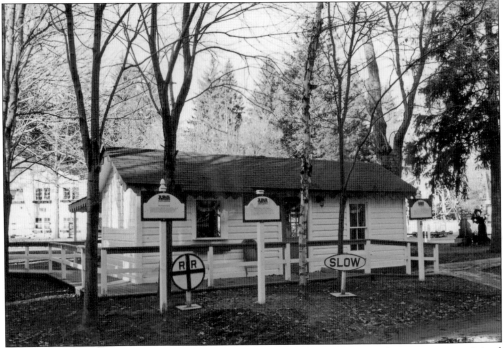

The LGV's oldest surviving building is the original Idlewild station. Now about twice its original size, it is located near the middle of Idlewild Park and displays LGV artifacts and memorabilia, reminding visitors of the LGV influence in the development of Idlewild Park.

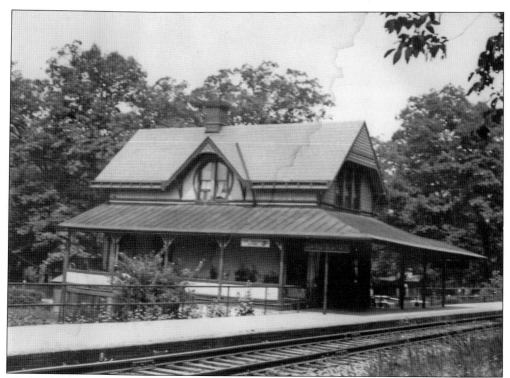

The Darlington station was located on the western edge of Idlewild Park. Built around 1896, the station served both Idlewild picnickers and the local community by including a convenience store in the lobby of the building. As seen below, the Last Run included a stop at the station.

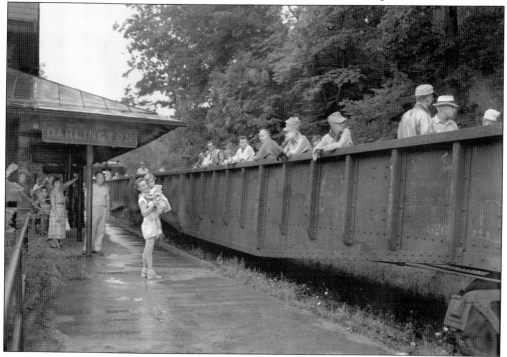

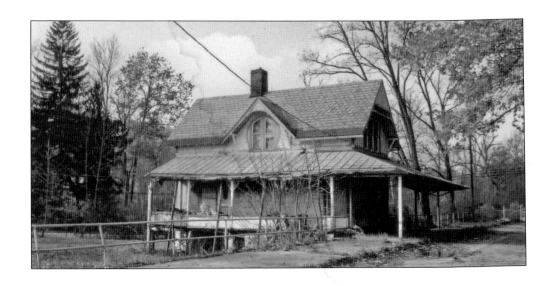

Idlewild Park assumed ownership of the Darlington station after the LGV shut down in 1952. The park maintained the property for many years, using the building for employee housing. At some point in time, park management decided that the expense of upkeep was too high. Once neglected, the grounds became overgrown, and the building fell into a state of disrepair. Idlewild Park delayed demolishing the building when it became aware of the existence of the Ligonier Valley Rail Road Association (LVRRA) in 2004. Knowing that the group's intent was to preserve the legacy of the LGV, Idlewild's general manager contacted LVRRA's board to discuss the possibility of the organization assuming ownership of the property.

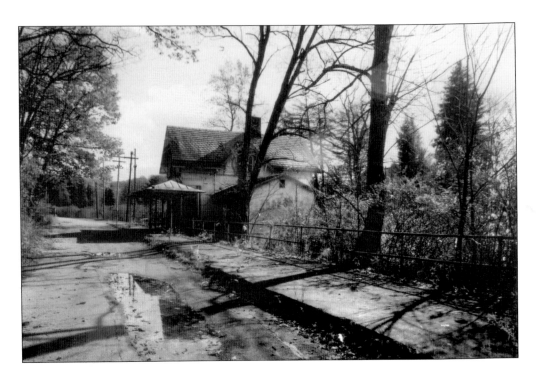

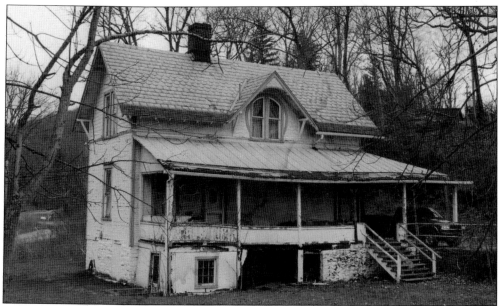

By 2006, the LVRRA agreed to accept Idlewild's offer of transferring the ownership of the Darlington station to the LVRRA. The decision to assume ownership of the station was greatly influenced by the integrity of the foundation and its plumb walls. However, the building still presented a frightening undertaking, with its collapsing porch, boarded-up windows, rotting wood, missing gutters, and peeling paint. With the support of Idlewild Park and the lead grant awarded by the Richard King Mellon Foundation, the project to restore the station began in November 2006. Through the generosity of numerous volunteers, individual donors, additional foundations, and the dedicated efforts of the members of its board, the LVRRA completed the restoration of the Darlington station by 2009. Soon after, the station was turned into the Ligonier Valley Rail Road Museum, which officially opened on May 20, 2010.

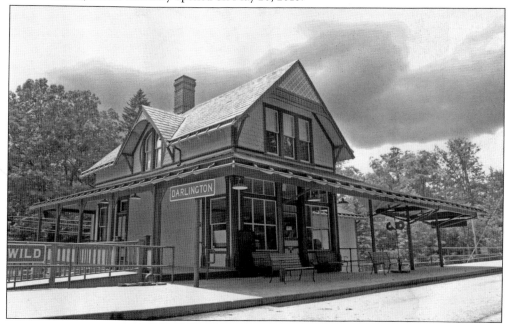

In 1952, when Bill Potthoff took this photograph of his sons standing beside the doodlebug at the Latrobe station, little did he know that his eldest son, also Bill, would grow up to become the president of the Ligonier Valley Rail Road Association. The younger Bill Potthoff is standing on the steps of the doodlebug between his brothers Fred (left) and Tom.

On October 11, 2006, ownership of the Darlington station was officially transferred from Idlewild to the Ligonier Valley Rail Road Association. Below, its cofounders, Bill McCullough (left) and Robert D. Stutzman, stand pondering the preservation and restoration project. They would never have believed that the restoration would be complete just three years later, or that the station would open less than a year after that as the Ligonier Valley Rail Road Museum.

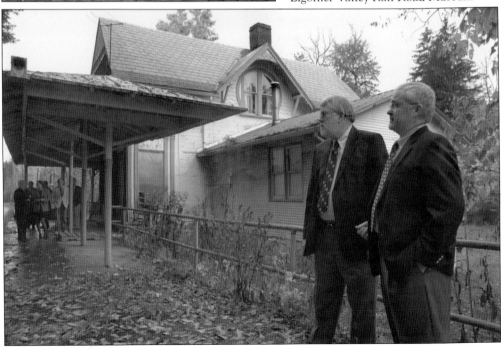

BIBLIOGRAPHY

Aldridge, James R. *Equipment Rosters of the LGV.* Unpublished manuscript, ongoing.

The Ligonier Valley Rail Road Museum website. www.lvrra.org.

Mellon, James. *The Judge: A Life of Thomas Mellon, Founder of a Fortune.* New Haven, CT: Yale University Press, 2011.

Myers, James Madison. "The Ligonier Valley Rail Road and Its Communities." PhD diss., University of Pittsburgh, 1955. Printed in Ann Arbor, MI: ProQuest Company, 2004.

DISCOVER THOUSANDS OF LOCAL HISTORY BOOKS FEATURING MILLIONS OF VINTAGE IMAGES

Arcadia Publishing, the leading local history publisher in the United States, is committed to making history accessible and meaningful through publishing books that celebrate and preserve the heritage of America's people and places.

Find more books like this at
www.arcadiapublishing.com

Search for your hometown history, your old stomping grounds, and even your favorite sports team.